D1211760

# THE EXPRESSIONISTS

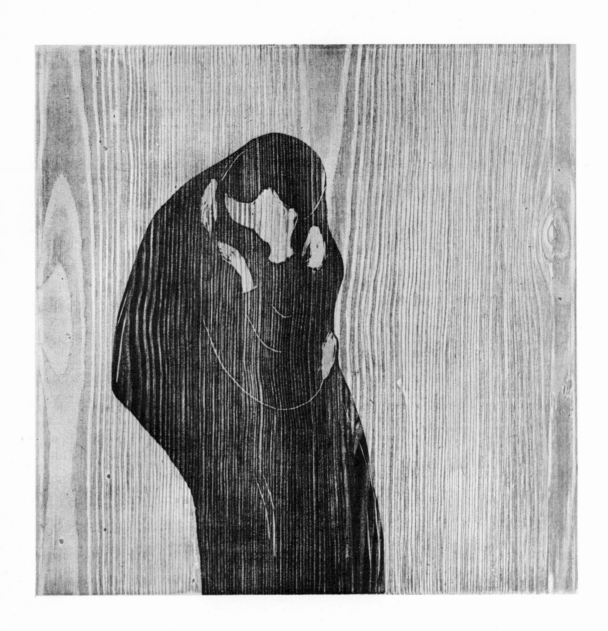

# THE EXPRESSIONISTS

## A SURVEY OF THEIR GRAPHIC ART

### TEXT BY CARL ZIGROSSER

GEORGE BRAZILLER, INC.

NEW YORK

# ACKNOWLEDGMENTS

In the preparation of this work many people have been most helpful. For their willing cooperation I wish to thank especially: Miss Martha Dickinson, Miss Una Johnson, Eberhard Kornfeld, William S. Lieberman, Miss Dorothy Lytle, Miss Elizabeth Mongan, J. B. Neumann, Dr. Jakob Rosenberg, Lessing J. Rosenwald, Carl O. Schniewind, Dr. W. R. Valentiner, and Kurt Wolff. The illustrations were made from prints in the collections of the following institutions and private collectors, and are reproduced by their courtesy:

Albion College Gallery of Art, Albion, Mich.
Art Institute, Chicago, Ill.
Brooklyn Museum of Art, Brooklyn, N.Y.
Mr. and Mrs. Erich Cohn, New York City
Detroit Institute of Arts, Detroit, Mich.
Fogg Art Museum, Cambridge, Mass.
Eberhard Kornfeld, Bern, Switzerland
Library of Congress, Lessing J. Rosenwald Collection
Metropolitan Museum of Art, New York City
Municipal Art Museum, Oslo, Norway
Museum of Modern Art, New York City
National Gallery of Art, Lessing J. Rosenwald Collection
J. B. Neumann, New York City
New Art Center, New York City
Philadelphia Museum of Art, Philadelphia, Pa.
University of Michigan Art Gallery, Ann Arbor, Mich.
Weyhe Gallery, New York City

I gratefully acknowledge these loans.

In the selection of the illustrations, I naturally drew largely upon the sources nearest at hand, my own museum and the Lessing J. Rosenwald Collection of the National Gallery, Washington. But these two institutions are by no means the only ones which have sizable collections of expressionist prints, nor does the number of prints borrowed from other places bear any ratio to their actual holdings. There are numerous private collections all over the country not drawn upon at all, as well as public institutions, such as the Museum of Fine Arts, Boston, the City Art Museum of St. Louis, or the Los Angeles County Museum. And finally, a thought in memory of the late Curt Valentin, who would have given generously of his aid and advice, were he still living.

CARL ZIGROSSER

Philadelphia Museum of Art
January 1957

Ⓒ George Braziller, Inc., 1957

This book was manufactured in the United States of America for George Braziller, Inc.,

EXPRESSIONISM has been one of the most exciting and influential art movements of the twentieth century, yet there seems to be little agreement among critics as to what the word actually means. The word has been applied not only to the visual arts but also to music, literature, and drama. It has been used to define an attitude or point of view, a technique or style, covering at times almost the whole of modern art and at other times the work of a specific group of German artists. The very origin and authorship of the word has been the subject of considerable debate among scholars.

Expressionism, as a deliberate artistic program, was a manifestation of the Post-impressionist era. Around the beginning of the twentieth century there was a widespread reaction against the exclusive attention of the Impressionists to surface phenomena, the study of light upon form in the open air. In Paris this led to Fauvism, Cubism, and other movements which stressed the formal and architectonic elements of design for their own sake. In Germany the counter-movement took a different turn, possibly more in keeping with a Nordic tendency toward introspection. The artists were subjective rather than objective in their attitude, valuing, as it were, inspiration above classic restraint, the dithyramb above the sonnet. They stressed what Paul Fechter called "the emotional experience in its most intense and concentrated formulation." Their keynote was the exploration—and even exploitation—of man's inner life. Of course this exploration was a twentieth century phenomenon that reached out into many other directions, including the discovery of psychoanalysis and the subconscious, significantly a

German contribution. What the Expressionists did was to develop techniques for projecting their discoveries in visual terms. The expressionist artist proclaimed his emotions at any cost—the cost often being, as Sir Herbert Read put it, "an exaggeration or distortion of natural appearances which bordered on the grotesque."

The expression of emotion in art is by no means a new or recent idea. There is an element of the emotionally expressive in all works of art. But because certain works are more expressive than others, most critics recognize that there is a tradition and background to expressionist art. Dr. Gustav Hartlaub, however, in his informed and discerning book Die Graphik des Expressionismus in Deutschland makes a distinction between expressive and expressionist. Both terms refer to the relation between the inner life of the artist and the outside world. The relation between the expressive artist and the world is affirmative in terms of love and confidence. The expressiveness appears in the choice of those things which appear to him beautiful or worthy of representation. With the Expressionist this affirmation is lacking. Nature for him is not an object to be interpreted lovingly, but rather to be torn asunder analytically. He operates upon it and by it to express an inner conception, something which he senses beyond things and their appearance, or which he has discovered symbolically through them. Such complete independence of so-called visual truth is possible only through an inner life so vivid and powerful that it can persuade and convince others, in a word, that his symbols, signs, or hieroglyphs have intelligibility beyond his private world. The modern artist has become very conscious of his mission as an independent creator, valuing it above all else.

Most of the German Expressionists were graphic-minded, and made prolific use of the three leading print mediums: the woodcut, the etching or drypoint, and the lithograph. It is with this aspect of their work that we are concerned in this book. Because they did not consider printmaking a minor or subsidiary art, but employed it as a major vehicle of expression, their productions now occupy an

6

important place in the history of graphic art. In general their aim was monumental and not illustrative. They expressed their own soul, and could not be bound to the literary or literal interpretation of another's work. In form and size as well as in subject matter their work had a grandiose aspect. In this respect their work differed from the fifteenth century German woodcut illustrations which they admired. What they learned from such woodcuts (1) (2) was a useful and appropriate technical language, the incisive and stylized handling of figure and landscape. The scale, however, was entirely different. The older works were small and designed for the printed page; the modern works, equally summary in treatment, were massive and overpowering. The Expressionists, as Dr. Edwin Redslob said of Kirchner, "once and for all, freed graphic art from the bonds of paper." The feeling for monumentality, therefore, is one of the hallmarks of the modern movement.

Another hallmark can be recognized in the overtones of feeling in modern works—an emotional tension which is sometimes carried to the extremes of hypertension. There is, to be sure, deep feeling in Gothic religious woodcuts; one senses in them an emotional tension commensurate with the situation, yet the tone is always more or less impersonal. The artist has subordinated his own self to work for the greater glory of God; he has identified himself merely with the tragic or joyous implications of the subject. The modern, on the other hand, pours into the conception an intensity of feeling over and above what may be appropriate to the dramatic exigencies. In this added stress and strain, there seems to be an almost obsessive self-assertion on the part of the artist, a work of emotional supererogation. Expressionist art is what it is, in Kasimir Edschmid's words, "because, proudly surrendering itself to the monstrous wounds of existence, it gathers fresh strength to act and to suffer."

The twentieth century, like the Renaissance, was an era of discovery, the recognition of new modes of expression in primitive and folk art, a revaluation of past art in terms of new lines of interest. African wood carving sug-

gested to the German artists a powerful technical instrument, not along the lines of analytical cubism as with the French, but of strongly plastic stylization and linear abstraction. In the work of certain older European artists, they also found inspiration and what Kirchner called "historical support." They looked with sympathetic eye at Baldung's personification of the wild and elemental forces of nature (4) or Seghers' contorted and writhing rock formations (5). And in Cranach's woodcut Christ on the Mount of Olives (3) with its swirling draperies and agitated landscape, they might see an exemplification of a device often used by them, the so-called pathetic fallacy. The attempt to endow inanimate objects with human feelings—however fallacious it may seem in realistic representations of nature—can be used effectively to reinforce a mood or project an artist's inner vision. Likewise, the Expressionist may be said to have a certain affinity with the mystic. Both live in a cosmos of their own imagination, quite apart from the workaday world. The mystic has experienced the ineffable vision which he tries to communicate to others as best he can. And therefore we may count such mystics as Jean Duvet (6) or William Blake (7) or Odilon Redon among the precursors of Expressionism. Their externalization of their inner world may not be violent or self-assertive. The mystic's province is religion, even if it be a private one, whereas the Expressionist's religion is self-expression in a modern world. The world has become noisier and more violent, and therefore the artist must shout all the louder to be heard. We have seen that religion, the episodes of the Christian epic, can be the vehicle for emotional expression of various kinds and degrees. Modern man has found, in addition, in the manifestations of abnormal psychology, in visions and dreams, in violent death and the macabre in general an expressive medium for emotional reactions. Some of these have been anticipated in the works of Goya (8) and Ensor (9).

The three artists of modern times who stood closest to the German Expressionists were Van Gogh, Gauguin, and Munch. Their life and works were a source of inspiration and encouragement. They were the pathfinders and led

the way over the mountains of indifference or hostility. It is difficult for us today, who accept Van Gogh and Gauguin as established old masters, to realize the opposition they faced and the moral courage they displayed in following their own star. Van Gogh may be accounted the true father of Expressionism. Without going into the details of his achievement, already so familiar to us, we need merely point out that his use of symbolic color and linear distortion is one of the basic tenets of Expressionism. The contrast between his early expressive lithograph Sorrow (12) and his later expressionist etching Portrait of Dr. Gachet (11) is a measure of the distance he traveled along the way. Gauguin likewise was consistently anti-Impressionist. "I am not," he wrote to Bibesco, "a painter after nature (today less than ever). With me everything springs from my mad imagination." His passion for the primitive and exotic struck a responsive chord in such painters as Nolde and Pechstein. His development of a new type of wood cutting opened up new vistas. "It is because these prints go back to the most primitive time of engraving," he wrote to Monfried, "that they are interesting. Wood engraving for illustration has become like photogravure, detestable." The blocks (13) (14) were cut, gouged, scratched, and sandpapered in unconventional ways to embody his inner vision of a Tahitian paradise.

Edvard Munch was the only one of the three who had any direct contact with German artists. He was par excellence the painter of individuality. Not only was his life the uncompromising assertion of his own individuality, but the individual was the central theme of his art: a human being under the sway of inexorable outside forces, such as death, sex, or nature. There is hardly any aspect of man and woman and their relation which he has not dramatized. We can mention but a few: Puberty (15) a young girl sensing with mingled awe and wonder the powers developing in her; Madonna (16), or the moment of conception, symbolizing the beginning and fate of Man as a supreme mingling of pleasure and pain—the ecstacies of consummation and the ashes thereafter; the threefold aspect of Woman (17) which Munch called the

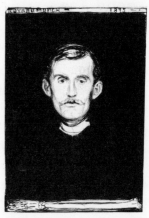

MUNCH, EDVARD (Norwegian, 1863-1944) SELF PORTRAIT, 1895, lithograph, 18 x 12⅝, Schiefler #31, Philadelphia Museum of Art.

virginal, the sensual, and the mystical, and which appears to be none other than Robert Graves' White Goddess of Birth, Love, and Death, the oldest European diety, worshipped as the New, Full, and Old Moon; the pathology of jealousy and melancholy and sickness (19) and death; the polarities of attraction and repulsion, ecstacy and despair (22). How does he translate such psychological penetration into perceptible form? Largely, like Rembrandt, by subtle nuance of expression based upon the veracity of inner experience. It is an imaginative and very personal approach. Munch once said—and it is the index of his divergence from the Impressionist formula—"I paint not what I see, but what I saw."

In the main, his work is more expressive than expressionist. Munch bears somewhat the same relation to the Expressionists that Degas does to the Impressionists: he was sympathetic to their aims but nurtured in an older tradition. The Expressionists try to say something new and seek new ways of saying it. The means is strongly affected by the content. Munch does say something which no one had dared say before, but does not say it in a fundamentally new way, with one important exception: his later woodcuts do foreshadow the technical methods of the Expressionists, and indeed had considerable influence upon them. He used plain pine boards, cut plankwise; and he composed freely with flat dark masses, indicated and broken up by sharp strokes of the knife and gouge, avoiding semitints. The effect was powerful and dramatic (23) (24). He was the first to use the accidentals of wood grain for aesthetic effect as in The Kiss (frontispiece). He also evolved a method of printing woodblocks in color by sawing the block in sections and printing separately. Munch made in all about eight hundred prints in all mediums.

The epoch from 1880 to the beginning of the first world war was one of unparalleled creative ferment all over Europe. It represented the assertion of individualism and freedom of expression, a critical examination of all conventions complacently held, exposure of social evils, prostitution, slums, working conditions, subjection of

women. One need but cite a few of the leading figures to suggest the spirit of the age: Debussy, Strauss, Bergson, Freud, Jung, Dostoievsky, Tolstoy, Chekov, Nietzsche, Zola, Verlaine, Mallarmé, Ibsen, Strindberg, Bernard Shaw, and Brandes. Such was the exciting milieu in which Edvard Munch was immersed and which in many ways he reflected and expressed. The symbols and pictures which he created out of his insight and experience will be appreciated as long as there will be individuals to value them, or indeed as long as the idea of the individual has any dignity or meaning.

The group of artists known as The Bridge (Künstlergemeinschaft Die Brücke) was the earliest manifestation of Expressionism as such. Their emergence coincided almost exactly in point of time with that of the Fauves in Paris. The events as they occurred have been well chronicled by Hans Bolliger and others. In 1905 Kirchner, Heckel, and Bleyl, fellow students at the architectural school in Dresden, and Schmidt-Rottluff, introduced by Heckel, banded together under the common name, Die Brücke, which name was suggested by Schmidt-Rottluff. They were ardent Nietzschians—Kirchner recalled that when he first met Heckel, the latter was declaiming from Zarathustra—and thus the name, The Bridge—to mastery and the future—was not without significance. It is possible also that their reading of the Birth of Tragedy at least encouraged their preference for Dionysian afflatus over Apollonian intellectual balance. In 1906, Nolde, Pechstein, and the Swiss, Cuno Amiet, joined and, in 1910, Otto Müller. Kirchner wrote a program which he cut in wood: "With faith in our potentialities and in a new generation of producers as well as appreciators, we call upon all youth; and as a youthful band and bearers of the future we seek the freedom to work and live as against the older well-settled powers. Everyone belongs to us who expresses his creative urge directly and without distortion." An associate Brücke membership of laymen and collectors was instituted, and they received an annual bonus of prints for their subscription. For about six years The Bridge issued publications and organized exhibitions with all the élan of a corporate movement. Their exhibi-

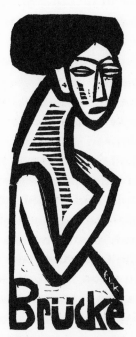

KIRCHNER, ERNST LUDWIG (German, 1880-1938) FIGURE, 1912, woodcut, 6 x 2¾, used on cover of Brücke Exhibition catalogue at Commeter Gallery, Hamburg, Eberhard Kornfeld.

tion catalogues were works of art, printed in a bold modern type with woodcuts as illustrations, in which members would reproduce, or rather interpret, one another's paintings. The artists were young and poor and enthusiastic. Schiefler has drawn a charming picture of their bohemian ways, their plain living and high spirits. During the winter they worked together, often in the same studio; they spent idyllic summers, at one with nature, sketching models in the open air. But, as was inevitable with such a body of powerful artistic temperaments, the group broke up in 1913, and the individuals went their separate ways. By this time most of them had left Dresden and settled in Berlin.

Ernst Ludwig Kirchner was perhaps the most original and dynamic of the group, and also the most prolific: his stupendous oeuvre of about twenty-four hundred prints is still in process of being catalogued. In addition, he executed paintings, water colors, tapestry designs, and countless drawings. He generally printed his own blocks and plates, and therefore his editions were usually small. He worked at white heat, often sitting before a stone or plate the whole night through. No other artist of the group was so aware of the innate capabilities of a particular medium, or worked so consistently within its limitations. His woodcuts, for instance, were not translations of drawings into wood: the concept and technical form were closely welded and grew from within. He likewise exploited the resources of the stone and the copperplate to a greater extent than the others. He worked much in color, on wood, stone, and even on copper. Concerned with recording his graphic work in all its variations of state, he collaborated patiently with his cataloguer, Schiefler, to set down all the details. The catalogue raisonné up to 1927, published in a limited edition of two volumes, was a handsome piece of bookmaking, embellished with many original woodcuts and typographic ornaments specially made for the purpose. Notable also was the volume of poems, Umbrae Vitae, by Georg Heym, executed entirely in wood, including text and integral illustrations. Kirchner was very articulate

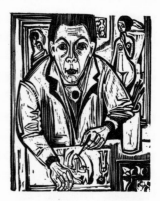

KIRCHNER, ERNST LUDWIG (German, 1880-1938) SELF PORTRAIT, 1921, woodcut, 18⅛ x 14¾, Schiefler #451, Detroit Institute of Arts.

12

and not at all blind to the worth or importance of his own work. Several eulogistic articles on him appeared in the publication Genius and elsewhere by L. de Marsalle, who, as it turns out, was actually Kirchner himself.

As an artist he was largely self-taught. He soon developed beyond his apprenticeship in Jugenstil or Art Nouveau. He went to the museums and studied the old German painters, and discovered the art of the South Seas and Africa (it seems probable that he made the discovery before the Cubists did). He sketched on the streets and evolved thereby a rapid and summary method of drawing. By about 1911 he had perfected his own style; and the next few years, until interrupted by the war, were fruitful and productive. There was another outburst of productivity after the war from 1917 to 1924. He was an artist who showed no diminution of creative power as the years went on. Toward the end he was experimenting with an exuberant, mobile line (possibly inspired by Picasso) to suggest movement and simultaneity. Contrast the monumental Portrait of Schames (30) with the later Portrait of Arp (36) or the two Swiss landscapes (32) (33).

Kirchner was tall, thin, but not robust in physique; he suffered from a fundamental weakness in the lungs. At the outbreak of the war, Kirchner, "an unwilling volunteer," was assigned to artillery training at Halle. No greater misfit in the German military machine could be imagined. It led to a complete physical breakdown; but, through the good offices of Prof. Paul Fehr, he was eventually sent to Davos in Switzerland, where in due course he regained some degree of health. But so great was his fear of being recalled to military duty—as revealed in the reminiscences of Dr. Fehr published by Eberhard Kornfeld in 1955—that he deliberately starved himself by stinting on his food, and thereby deceived even doctors and specialists into certifying him as incurable. As soon as the danger was over, he recovered rapidly. The event is cited to show the terrific will power of the man. It also explains, as Dr. Jakob Rosenberg has pointed out,

how a person at death's door with tuberculosis could have produced so much work of the highest quality during the year 1917 and after. He later settled down near Feldkirch; and Switzerland became his second home until, depressed by the triumph of the Nazis and the confiscation of his art in Germany, he committed suicide in 1938.

He was, one might say, a completely dedicated artist. He was self-centered: religion, politics, social values mattered little to him, only the will to create in plastic terms. He had little regard for subject matter as such; it was merely the framework on which to pose an aesthetic problem or make visible his inner conception. His themes comprised city streets and scenes of Berlin night life before the war, mountain and pastoral life in Switzerland after the war, and nudes, figure compositions, and portraits at all times. His scenes of night life were not realistic in the sense that Lautrec's comparable renderings of Paris project a complete milieu, but they convey a feeling, the characteristic feeling of Berlin before the war, which no other artist has achieved. Likewise his Swiss prints convey the feel, but not the detail, of pastoral life in the mountains. His portraits in their endless variety and plastic realization are perhaps more significant as works of art than as portraits. The outstanding quality of his work is its feverish intensity, a combination of vital power and extreme sensibility. Kasimir Edschmid once characterized Kirchner as a wolf driven to madness by a ghost; and, though the simile may seem strained, it does convey some idea of the desperation in his will to create. The very intensity of his drive may be in part a compensation for his physical weakness and a frantic determination to overcome it—"illness often forces me to rest when I would like to create." None of this debility ever appears in his work: he had a sane and healthy outlook. His expression was at all times extremely sensuous, based on his conviction that "the nude is the foundation of all plastic art." In the early Brücke days he announced his program as "the ultimate unity of Man and Nature." In a letter to Curt Valentin the year before his death, he wrote: "My goal was always to express emotion and

14

experience with large forms and simple colors, and it is my goal today . . . I wanted to express the richness and joy of living, to paint humanity at work and play in its reactions and interreactions, and to express love as well as hatred."

If Kirchner was a rare combination of power and sensibility, Erich Heckel shows, in the last analysis, more sensitiveness than monumentality. The highstrung angularity, the nervous rhythm, and the expressively surcharged colors of his Self Portrait (39) are an index of the man as well as of his work. There is an almost neuraesthenic susceptibility in him that prompts his compassionate delineation of the sick (99) and of the wounded during the war, when he was attached to a hospital in Flanders; and likewise an idealizing tenderness that makes him a sympathetic interpreter of young girlhood and young womanhood, as in the drypoint Reclining Girl (26) and in various other woodcuts in black and color. Heckel has a feeling for landscape which is more romantic and intimate than grandiose. His Snowstorm (40) for all its rhythmic accents, or his Girl by the Sea (41) for all its ecstatic tensions, have something cozy and delectable about them. His Fjord Landscape (43) is pure serenity. He has made about six hundred prints, but after the Nineteen-twenties the intensity of his Expressionist drive abated considerably.

Karl Schmidt-Rottluff has an entirely different temperament—sturdy, solid, imperturbable, but with a capacity for exalted vision. His first prints were lithographs, but eventually he found in the woodcut his favorite medium of expression. In his oeuvre of over five hundred prints, more than three hundred are woodcuts, the balance being approximately divided between lithographs and virile drypoints. During the productive years of 1913–1914 he attained mastery of his personal style—a type of tightly-knit and enclosed composition with dynamic balance of black and white (45) (46). The formal elements are strong, but are kept from lapsing into a contrived formula only by the artist's deep feeling. In his striving for monumental figural form, he found inspira-

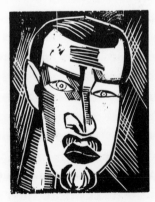

SCHMIDT-ROTTLUFF, KARL (German, 1884-    ) SELF POR-TRAIT, 1916, woodcut, 11⅝ x 9¼, Schapire #190, Brooklyn Museum of Art.

tion in the abstractions of African sculpture. His graphic expression reached perhaps its highest point in the great religious woodcuts of 1918–1919. The war, with its impact of suffering and death, had driven him to a reconsideration of the eternal verities. His interpretations of the scriptural legends display a grandeur and loftiness of feeling which have been seldom surpassed in modern graphic art. Everything superfluous, sensuous, or temporal has been deleted; what remains is pure universal expression (47) (48). Since about 1930 he has given up printmaking to devote himself almost exclusively to painting. It is curious that he has made very few color prints (50). It is as if he keeps his painting and printmaking in separate categories, and as if in printmaking he relies more upon the uncompromising structure of black and white, abstracting the element of sensuous color.

Emil Nolde was older than the other Brücke artists, and came to the group as a mature artist. He withdrew after a year and a half, because he felt there was too much of a sameness in the work of the group. He did, however, learn the technique of wood cutting and printing from Kirchner, and made in all about two hundred woodcuts characterized by strong contrasts in black and white (but more in the sense of brush drawings than of working on wood) as in the noble Prophet (53) and in Jestri (54). He also made about two hundred etchings and lithographs, including some in color (56). Glaser considered his lithographs rather posterish, and rated his etchings and aquatints as his finest graphic achievement (55). Nolde was in many respects a baffling and enigmatic artist, independent and unclassifiable, and rather uneven in his production. He had a heavy-handed, almost grudgingly boorish sense of humor that sometimes lapsed into the banal. This heavy-handedness may possibly have been inherited from a long line of peasant ancestors, as was perhaps his fondness for the grotesque and demonic. Yet he was capable of a light touch, as in his Nude (27). He must have had a fascinating personality. He married a famous Danish actress, and moved much in other than artistic circles. Most of the people who knew him person-

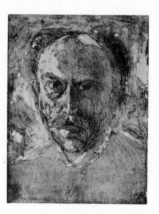

NOLDE, EMIL (German, 1867-1956) SELF PORTRAIT, 1908, etching & aquatint, 12 x 9¼, J. B. Neumann.

ally spoke of him in the highest terms; indeed, he has been more extravagantly praised than almost any other German artist. Even so different a person as Paul Klee apostrophized him as "that age-old soul, Nolde." Yet Edschmid maliciously called him a "tapir with more mass than content." Nolde must have rather deliberately tried to reconcile within himself the most diverse elements, for as early as 1901 he wrote that the great artist should be all things: "natural and cultivated, godlike and beast, a child and a giant, naïve and sophisticated, displaying feeling and understanding, passionate and detached."

Mention should be made of Christian Rohlfs, a friend of Nolde and, like him, an old and established artist. He had no direct connection with the Brücke group. But at the age of sixty he became converted to Expressionism, and from 1908 to his death in 1926 he made 183 woodcuts and linoleum cuts (82). His simplified and deeply felt religious prints are perhaps his highest achievement. Lovis Corinth, one of the old masters of German Impressionism, also moved in his later years toward a more Expressionist emphasis. Most of his graphic work does not fit into this later phase, but his Self Portrait is included for the sake of historical completeness (80).

Kirchner recounted in his unpublished Chronicle how the Brücke artists met Otto Müller in 1910: "In his studio they found Cranach's Venus which they also greatly admired. The sensuous harmony between his life and his work made him a member of the group as a matter of course. He brought us the charm of distemper painting." He was sweet natured and serene in temperament, and had no need to search passionately for an ideal world as the others did. "He carried his Tahiti in his blood," as Leopold Zahn said, for his mother was a gypsy. He depicted many idealized scenes of gypsy life. He also made numerous lithographs (59) and a few woodcuts (60), glimpses of an unreal arcadian world, young boys and girls bathing or sunning themselves among the reeds. His work has a certain sweetly adolescent and poetic charm, but is monotonous when seen in large numbers.

Max Pechstein, like Nolde, did not remain long in the circle of Die Brücke. He was always making new alignments, and his restless search for what was new and useful and à la mode drove him as far afield as Paris and the South Sea Islands. A facile artist, albeit eclectic and superficial, he had the qualities and drive that made for quick success. With it all, there was a certain robustness in his nature, an extrovert joy of life. His forms were full, not niggardly, even if a bit vulgar. His etchings of hand-to-hand fighting in the war were documents of a kind.

In 1912 the Brücke group was invited to take part in an exhibition of prints and drawings organized by the Blaue Reiter (Blue Rider) group in Munich. This group, led by Kandinsky, included Franz Marc, August Macke, Jawlensky, Campendonk, Klee, and Kubin. They dreamed of a great synthesis of the arts, hospitably welcoming all that was new and revolutionary in music (Schönberg) and art: German and French and Russian; folk art (Bavarian glass painting); the art of children and primitives like Douanier Rousseau (10); old woodcuts (2) and (4); exotic and ethnographic art. Much of this program was summarized in the yearbook Der Blaue Reiter of 1912, an enthusiastic testament of faith which is one of the important art documents of the time. In the actual work of the Blue Riders, the original Brücke Expressionism was somewhat modified by a greater trend toward abstraction and a mystic emphasis on inner experience. Whatever grandiose plans the Blue Rider group may have had were blasted by the war. The Russians, Kandinsky and Jawlensky, had to leave the country; and Marc and Macke fell at the front.

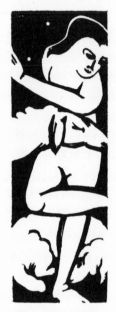

MARC, FRANZ, (German, 1880-1916) SHEPHERDESS, 1912, woodcut, 8⅝ x 3, signed and numbered 1, ex. coll. Stinnes, Philadelphia Museum of Art.

Kandinsky had only an indirect relation with Expressionism in its strictest sense. At this time he was already developing his concept of abstract, or absolute painting, as he called it, in which all representation of natural objects was eliminated, and in which color, line, and plane in themselves produce emotional response. The woodcut which accompanied his volume of poems Klänge (62) had not quite reached the absolute stage. There was

some representation of natural forms, but often of ambiguous meaning—his theory of improvisation allowed subconscious elements to slip out into expression.

Franz Marc was one of the most attractive and engaging personalities in modern art. The warmth of his response to life, a mystical identification with all nature, both organic and inorganic, was set sharply in focus by his untimely and tragic death in the war. In his short life he made seventeen early lithographs and, during the years 1912–1914, twenty-one woodcuts including four in color. In his woodcuts he made use of salient lines and flat silhouette-like masses, depending upon gesture and placement to suggest in essence the fierceness of the Tiger (64) or the fecund germination of Genesis II (65). In the Annunciation (63) the emphasis was directed upon the inner feelings of Mary, feelings so exalted that for the moment they had become cosmic and were shared by all creation. Everything in the picture—the design, the darting rays, the staccato accents—contributes to the feeling of tingling rapture.

August Macke made very few prints, just a few linoleum cuts (66), before his ill-fated death. He was what the Germans call a Sonntagskind, a Sunday-child, a gay and richly-endowed nature. He had many contacts with French artists, in particular with Delaunay, whose Orphic cubism also influenced Marc and Klee.

Paul Klee was one of the most original and important artists of the Expressionist generation, or indeed of twentieth century art in general. His expression was intensely and uniquely personal, a perfect blending of form and content. He was endlessly inventive. Seemingly naïve and child-like, his work displayed the ultimate sophistication. He aimed to incarnate the intangibles of fantasy, dream, and memory. "Art," he once said, "plays an unwitting game with ultimate things, but reaches them nevertheless." The titles, which he so neatly put on almost all of his works, were very important, not because his work was illustrative or dependent upon titles for

exegesis, but because the title was another and coördinate aspect of the inner concept, whenever form and content were so closely knit together. He made about one hundred and fifty prints, mostly etchings and lithographs with but few woodcuts (37) (69) (70). His writings, even the dry pedagogical parts, have their own originality. "My earthly eye is too far-sighted and most often sees through the most beautiful things. (And it is often said of me; 'He does not see the most beautiful things.')"

Heinrich Campendonk was very strongly influenced by his friend Marc. In his woodcuts he achieves a fairy tale dreamlike effect by alternations of black and white and a deliberate distortion of perspective, whereby background and foreground are inextricably mixed (67).

At the time of his association with Der Blaue Reiter, Alfred Kubin was, next to Kandinsky, the best known member of the group. He is both a writer and painter. His expressionist novels, particularly Die Andere Seite (The Other Side), influenced Kafka and other younger writers. He is a prolific graphic artist, and has illustrated about seventy books besides issuing numerous portfolios and single lithographs. His prints are largely transcriptions of pen drawings on stone with no special feeling for this medium (100). It is for his fantastic subject matter that he is best known, resembling Ensor in his interest for the visionary and macabre.

Among the artist-teachers of the Weimar Bauhaus was an American, Lyonel Feininger. He had originally come to Germany to study music; he remained to become an artist. As with his friend Klee, music meant much, and his art is understood through it—Bach and complex contrapuntal organization. In close touch with modern movements in Germany—Die Brücke and Der Blaue Reiter (with whom he also exhibited)—he also had connections in Paris with Delaunay and others. He found in a modified cubism a language suited to his needs. In his earlier work, he tended to distort the figure in witty and amusing ways, for he had started out as a caricaturist. Later he molded space and architecture into crystalline shapes. His wood-

cuts (71) (72) and the less frequent etchings and lithographs, all have a special quality akin to the absoluteness of music, intricate compositions of lines and planes and rays of light.

Most critics agree that Oskar Kokoschka is a typical German Expressionist, even though he came from Austria and did not belong to any of the original groups. Curt Glaser's not too sympathetic critique could easily be applied to other extreme forms of Expressionism: "He is concerned with heightening the expressive content of experience so far that it becomes a pathological deformation of reality; and he gives shape to his dream-like inner visions in forms that are ecstatic and frenzied to the degree of self torment." Like Munch, he issued sequences of lithographs, with a misogynist slant, dramatizing the misunderstandings and antagonisms of the sexes. In Columbus in Chains (73), for which he also wrote the text, he shows how his hero explores a mysterious unknown country called Woman, endures vicissitudes of experience, only to go down to defeat with the ultimate triumph of the Female. In the Bach Cantata (74), using the framework of a musical composition, he created another dramatic sequence with a slightly less pessimistic ending. He likewise executed a series of lithographs giving a new interpretation of the Passion (75). He is famous for the acute psychological perception of his many portraits in oil and lithograph, yet they are always seen through the lens of his personal sensibility. He also drew on stone a series of large and impressive womanly types, The Daughters of the Covenant, of which Esther (76) is a characteristic example. The full intensity of his Expressionism has diminished in later years, but when the fury was on him, formal techniques and all the polite conventions were tumultuously swept aside in a frenzy of self-expression.

Carl Hofer was independent of the main body of Expressionism. He was a distinguished painter whose extended sojourn in Rome, Paris, and Switzerland gave him a broader outlook and molded his expression in more classic forms than most of the German artists. He did, however, have an Expressionist phase, reflected in the

**lithograph** Novitiate **(77)** which depicts the emotional crisis of a novice about to become a full-fledged nun. His Girl and Moon **(78)** maintains a nice balance between emotional overtone and formal interest; and his Sokotra **(79)** is a moving dramatization of the ecstacy of lovers at one by the sea shore.

Of all the German sculptors, Barlach was perhaps the most consistently Expressionist. He wrote plays—some illustrated with lithographs—which were produced, and received serious consideration among students of expressionist drama. But his most important and solid contribution was in his sculpture and woodcuts. His art grew out of medieval and folk art, and bore a monumental solidity. It is extraordinary with what intense feeling and elemental power he could endow his work. In his autobiography he spoke of the astounding realization that came over him: "that you may dare without reserve to give out your very own—the innermost as well as the outermost, the gesture of blessing or the blast of wrath—since expression of everything is possible, whether it be a hellish paradise or a heavenly hell." His graphic oeuvre comprised about two hundred prints. Though he produced numerous lithographs, as in Rebellion **(85)** and, not without a touch of earthy humor, in Judgment Day **(86)**, he found in the more resistant material of wood a medium more befitting his nature. "The woodcut," he wrote his cousin in 1920, "demands complete avowal, an unequivocal precipitation of what one really means. It dictates a certain universal expression and rejects an amiable or easy solution." He has admirably expressed the polarities of joy and despair in the two woodcuts reproduced (83) (84).

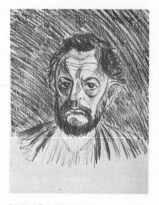

BARLACH, ERNST (German, 1870-1938) SELF PORTRAIT I, 1928, lithograph, 14 x 12¾, National Gallery of Art, Lessing J. Rosenwald Collection.

Käthe Kollwitz has testified to the impression which her close friend Barlach's woodcuts made upon her when she first saw them in 1919. They inspired her to take up the medium, though not to imitate his style, for she had her own personal way of looking at things. She arrived at Expressionism later in life; the experience of the war and its aftermath seemed to demand a heightened emotional

22

expression. In Volunteers (87) we sense the almost hysterical feeling of dedication to service which animated the youth of all countries. And in the two disquisitions on the theme of death (88) (89), which occupied her at the end of her life, we recognize an intensity of expression which is both appropriate and aesthetically satisfying.

Lehmbruck, in whatever medium he undertook, always remained the sculptor; and his etchings and lithographs, about seventy-five in number, were, with few exceptions, pure studies in sculptural form, universal in theme and monumental in feeling. For him "there is no monumental architectonic art without contour and without silhouette." His figures live in an isolated ideal world, brought to life and feeling by his masterly and form-shaping line and by their rhythmic and expressive gestures (90) (91). His Macbeth (96) is in a different and more unusual vein, an overwrought and almost melodramatic personification of a murderer's feelings.

With Gerhard Marcks, the sculptor, as with Carl Hofer, the painter, Expressionism is but one of the factors which shaped his personal style. His sculpture represents a rare fusion of classical and Gothic elements, and derives vitality and poised inner integrity from both. The period of his greatest activity as a printmaker was in the early Nineteen-twenties when he taught at the Bauhaus, along with Kandinsky, Klee, and Feininger. His woodcuts are cast in linear terms within the great graphic tradition, neither boringly old nor blatantly new. They display wit and humor and a quiet detached wisdom that stands apart from the hectic tempo of the time. They are original and never repetitious in subject or treatment. Their sapient wit is perhaps their most striking feature. Consider, for example, with what felicity he has suggested in Cats (92) the conflicting feelings of pride and envy, the feline character, the catiness of the cat. Note also the resemblance between the peasant and his cow (61), and in Drummers (94) how the vertical strokes of the background suggest and, indeed, reinforce the rumble of the drums. He has continued to make a few prints now and then. The

impressive Angel of Cologne **(95) is one of the most recent. The woodcuts of Gerhard Marcks are the least known part of his oeuvre, and therefore the most underrated.**

**The sculptor Ewald Mataré exploits flat shapes and surfaces rather than line in his woodcuts, which often appear in color.** Cows Grazing at Night **(81) is a charming and witty stylization of primitive forms.**

**A little known printmaker, Paul Gangolf, deserves wider acclaim. Although Schiefler, the pioneer collector and cataloguer of Munch, Kirchner, and Nolde, collected his work and wrote about it, and although J. B. Neumann published several portfolios of his lithographs, his productions have fallen into almost total eclipse. He made a few woodblocks and, at Schiefler's instigation, some etchings, but his lithographs, especially those with scratched designs on a dark background, are possibly his most original contribution. The** St. Anthony **(101) does seem to suggest the phantasmagoric quality of the saint's torment.**

**In 1912 Herwarth Walden organized at Sturm a group exhibition of the work of three artists, R. Janthur, Ludwig Meidner, and Jakob Steinhardt, under the title of** Die Pathetiker **(The Suffering Ones). They were united in their extremely emotional approach to art. Meidner (97) was rather bohemian in his personal life (Grosz painted a malicious and devastating picture of him in his autobiography), but moved on a highly charged emotional plane. Steinhardt (98) has outgrown the melodramatic tensions of the early period to become the dean of graphic artists in Israel.**

**A reaction to the extreme forms of Expressionism took place around the mid-twenties in Germany. The reaction was against the too exclusive preoccupation with transcendental problems and with introspective states of the artist's soul, which practically took the form of escapism. Certain artists felt they could no longer ignore the sad and tragic condition of life in Germany—hunger, poverty,**

inflation, political unrest, and the like. Their attitude became one of cynical acceptance of conditions and a brutal, factual statement of them, under the slogan of the New Objectivity (Die Neue Sachlichkeit), a name coined by Dr. Hartlaub, who feels that it took on later a too definitely political slant. One of the leaders of the movement, which also included Georg Scholtz and Otto Dix, was George Grosz. He presents a searing picture of the seamier aspects of German life, unforgettable types of the military, the Prussian functionary, the get-rich-quick speculator, the war-maimed and hungry, and all the sordid aspects of sex. He was, however, more than just a reporter without emotional participation. He was, one might venture to say, a disillusioned idealist; and his autobiography—as significant for what is left out as for what is said—gives little clue to the real cause of his blighted hopes. He merely states: "My drawings expressed my despair, hate, and disillusionment. I had utter contempt for mankind in general. I drew drunkards, puking men . . . I drew a cross-section of a tenement house: through one window could be seen a man attacking his wife with a broom; through another two people making love; from a third hung a suicide with body covered by swarming flies." He evolved a style of drawing—and his many lithographs are merely drawings multiplied on stone—aptly suited to his purpose, a schematic linear outline (104) (105) or a kaleidoscopic jumble of simultaneous aspects (102). Grosz later came to America to find a new direction and a less bitter outlook on life. "These drawings had served their purpose. For me they now belonged to the past." They have a bite which his later works lack.

Otto Dix, not so politically or socially conscious as Grosz, presents an equally depressing panorama of sordidness and degradation. There is something hard and brutal and basically vulgar in Dix: one does not sense in him, as one does in Grosz, any degree of moral revulsion. In fact, he deliberately exploits the tawdry and sensational. The one great work which displays his talent at its best is the sequence of fifty etchings and aquatints on War (110). It ranks, along with the series by Callot and Goya, as one

of the terrific indictments of war. For all its harrowing details, it has a kind of dignity that is lacking in his other prints.

Paul Kleinschmidt, a pupil of Corinth, executed numerous etchings and drypoints that bear some affinity to the social commentary of Dix and Beckmann. Occasionally, as in Odalisque (109), they have a slightly satiric flavor. Other German artists, as, for instance, Jansen in his woodcut series (107), produced satiric documentaries much in the spirit of the movies of the time. The Belgian, Frans Masereel, cut voluminous sequences and single prints on wood in similar vein (106). Mention should be made also of Karl Rössing, whose wood-engravings, particularly as assembled in the volume Mein Vorurteil gegen diese Zeit (My Prejudice against these Times), display his satiric revulsion against the Vanity Fair which was Germany.

It is difficult to fit Max Beckmann into any rigid classification. In so far as he viewed the spectacle of human folly with uncompromising frankness, he could perhaps be labeled a New Objectivist, just as he was a true Expressionist in his passionate dedication to the expression of an inner concept. Kasimir Edschmid spoke of his overpowering maleness, and likened him to a bellowing bull. Meier-Grafe spoke of his capacity for, and receptivity to suffering in such terms as "monomania of horror" and "voluptuousness of anguish." Today, with an added perspective, we know that behind the male arrogance and the martyr's torment was an all-consuming passion for self-realization and self-expression, an expression of a very special kind: the projection of his own concept of the world he lived in. This intuition of his could not rest content with a mirror-image of outward appearance, but must penetrate beyond to a universal reality. He essayed the mightiest task of all: to envision the world sub specie aeternitatis and to embody his vision symbolically, for it could be done in no other way. His transcendental illumination cast a spell of hallucination over the characters in his pictures. They appeared as automata, as somnambulists, driven hither and yon, for good and for evil, by forces they knew not of. Such was the burden of his

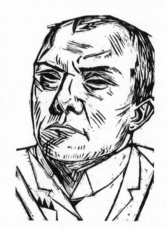

BECKMANN, MAX (German, 1884-1950) SELF PORTRAIT, 1922, woodcut, 8¾ x 6⅛, Glaser #200, Probedruck, Brooklyn Museum of Art.

endeavor, at first dimly realized but gradually leading up to the great allegories of the later years. Beckmann made, in all, about three hundred prints, chiefly etchings and lithographs and a dozen woodcuts. Relatively few were produced after 1925, the fifteen lithographs of Day and Dream (1946) being a notable exception. The prints seem more closely related to the artist's role as observer than as mystical seer, witness the Declaration of War (112) the Königin (or Queen's Bar) (115), and the powerful landscape impression Beach (116). But Dressing Room (114), Dream (117) and Night (113)—that grisly apotheosis of cruelty and suffering from the equally gruesome sequence called Hell—seem to be a slight foretaste of the visionary Beckmann.

Expressionism may have started as a German phenomenon, but the idea in its broader sense has taken root in other countries also. The protean Picasso passed through what might be called an Expressionist phase (118). Of course, all his work is directly or indirectly expressive, definitely committed to the expression of inner feeling. It is interesting, however, that in 1935 Picasso should have said to Zervos: "What forces our interest is Cézanne's anxiety—that is Cézanne's lesson; the torments of Van Gogh—that is the actual drama of the man. The rest is sham." Of course, Rouault is the great exemplar of French Expressionism; and his achievement is so familiar that we need not elaborate on it here. Our example is taken from the monumental sequence Miserere et Guerre (119). The whole Fauve group (Matisse, Dufy, Derain, Van Dongen, Vlaminck) had some affinity with Expressionism in its short-lived association. Douanier Rousseau (10) and folk artists in general were admired by the Expressionists for the directness of their vision and an intensity unhampered by academic discipline. Van Dongen and Delaunay had personal contact with the Germans. The Russian, Chagall, lived in Germany and was associated for a time with Herwarth Walden's Sturm. His paintings and prints are expressionist in tone, possessing a fantastic dream-like humor and a wealth of imagery drawn from Jewish life and mysticism (120). Among the Americans, whose work of the period bears

some relation to Expressionism, is Max Weber. His wood-cuts, though tiny in size, have a monumental feeling (121). John Marin's expressionist interpretations of New York (122) are quite early, and his statement about them, made in 1913, is pure expressionist doctrine: "If these buildings move me . . . it is this moving of me which I try to express, so that I may recall the spell I have been under, and behold the expression of the different emotions that have been called into being."

One must not minimize the effect that the first World War had on the unfolding of Expressionism. The war and its aftermath were a great shock and, indirectly, a provocation to the German artists; and Expressionism did not really come to full fruition until the days of the Weimar Republic. It was a feverish period of wild experiment, of introspective self examination, of guilt and revulsion against militarism, of hunger and suffering. There was emotional inflation as well as monetary inflation. The artists believed that cultural values might at last triumph over destructive forces, and that a bright new era of civilization was at hand. Everybody rushed headlong into experience. Old habits, the old stabilities were crumbling; everything was seething and in flux. For the artists, the real ones capable of deep feeling, it was a period of agony and soul searching. Before the war, Brücke and Blaue Reiter were little national groups, splinter movements like Fauvism or Orphism. The war indirectly gave them depth and breadth, and Expressionism emerged as a world-wide school.

Some of its manifestations in the past may have been extreme, pathological, even hysterical, and therefore open to ridicule and parody. One could easily poke fun at the extravagant conceptions of the minor artists, and even at such works as Munch's Madonna or Kokoschka's Bach Cantata. But behind all the disconcerting foolishness was an idea. The artists dared to explore regions where safe and sane folk would not venture. If they got themselves all tangled up, at least they had made a discovery. And we can discover many things from exaggeration, since the abnormal is merely the normal carried to an

extreme, where it can be clinically isolated and observed. Witness what we have learned from Freud. It must be admitted that the inflationary period in Germany encouraged a large number of mediocre and unqualified artists, for, when money has no value, people will buy anything tangible, even a third-rate print. It is usually the imitators who are more extravagant than the innovators. The masters really wrestle with the conception or the material, and thereby develop balance and personal style. With sweat and tears they lay down a path, and the followers come galloping after.

The background to Expressionism has been treated at some length to point up its importance as an historical art movement. Indeed, Sir Herbert Read specifies Expressionism as one of the three basic approaches to art in general, the other two being the realist and the idealist. Expressionism is still a vital influence today. Its techniques are particularly adapted to express the tensions of our atomic age. And one could cite a long list of living artists in every country who may be called Expressionists. Even in the abstract field, the Abstract Expressionists, with their emphasis on interior movement and militant affirmation of personal sensibility, testify to its influence, as their very name implies. Unfortunately limitation of space precludes further exposition. Indeed, the vast bulk of twentieth century Expressionism has merely been summarized. We have been looking at the apex of the pyramid and have overlooked its base. The names and accomplishments of many artists have necessarily been omitted. But sufficient data has been presented to tell the story of the Expressionists in its broadest outline. It is an exciting story, for the Expressionists cared terribly about art. They were individualists, most of them, but their collective impact was far-reaching. Their achievements were distinguished, and their aspirations were boundless. Like gods they would create the world in their own image.

# NOTES TO THE REPRODUCTIONS

FRONTISPIECE: **MUNCH, EDVARD (Norwegian, 1863–1944) THE KISS, 1902, color woodcut, 18¼ x 18¼, Schiefler #102, Museum of Modern Art.**

1. **GERMAN SCHOOL (XV Century) TUMBLERS, 1475, woodcut, 3¼ x 4⅝, from Rodericus Zamorensis,** Spiegel des Menschlichen Lebens, **Augsburg, G. Zainer, 1475, Library of Congress, Lessing J. Rosenwald Collection.**

2. **GERMAN SCHOOL (XV Century) EXPULSION FROM PARADISE, 1479, woodcut, 4½ x 7¼, from** The Bible, **Cologne, Bartholomaeus von Unkel, 1479, Philadelphia Museum of Art.**

3. **CRANACH, LUCAS (German, 1472–1553) CHRIST ON THE MOUNT OF OLIVES, ca. 1502, woodcut, 15¼ x 11, unique proof, Metropolitan Museum of Art.**

4. **BALDUNG, HANS (called GRIEN) (German, ca. 1476–1545) WILD HORSES, 1534, woodcut, 8¼ x 12¾, Bartsch #56, National Gallery of Art, Lessing J. Rosenwald Collection.**

5. **SEGHERS, HERCULES (Dutch, ca. 1590–ca. 1645) ROCKY VALLEY, ca. 1630, etching, 4¼ x 7⅜, Springer #12, National Gallery of Art, Lessing J. Rosenwald Collection.**

6. **DUVET, JEAN (French, 1485–ca. 1561) ST. JOHN SUMMONED TO HEAVEN, 1561, engraving, 11¾ x 8½, from the set of the** Apocalypse, **Dumesnil #29, National Gallery of Art, Lessing J. Rosenwald Collection.**

7. **BLAKE, WILLIAM (English, 1757–1827) TO ANNIHILATE THE SELF-HOOD OF DECEIT, relief etching printed as a woodcut and colored by hand, 6¾ x 4⅜, from** Milton, **1804–1815, Library of Congress, Lessing J. Rosenwald Collection.**

8. **GOYA Y LUCIENTES, FRANCISCO (Spanish, 1746–1828) BOBABILICON, ca. 1813–1820, aquatint, 9½ x 13⅞, Delteil #205 ii/iii, Philadelphia Museum of Art.**

9. **ENSOR, JAMES (Belgian, 1860–1949) DEATH PURSUING HUMANITY, 1896, etching, 9¼ x 7, Philadelphia Museum of Art.**

10. **ROUSSEAU, HENRI (Le Douanier) (French, 1844–1910) WAR, 1895, lithograph, 8½ x 12½, Philadelphia Museum of Art.**

ERRATA: Illustrations 35 and 81 have been reversed; 35 is by Mataré, 81 by Kirchner.

11. VAN GOGH, VINCENT (Dutch, 1853–1890) DR. GACHET, 1890, etching, 7⅛ x 6, Philadelphia Museum of Art.

12. VAN GOGH, VINCENT (Dutch, 1853–1890) SORROW, 1882, lithograph, 15⅛ x 11¼, Museum of Modern Art.

13. GAUGUIN, PAUL (French, 1848–1903) NAVE NAVE FENUA (DELICIOUS EARTH), 1894, wood-engraving, 14 x 8, Guérin #94, Philadelphia Museum of Art.

14. GAUGUIN, PAUL (French, 1848–1903) MANAO TUPAPAO (THE SPIRIT WATCHES), 1894, color woodcut, 8⅞ x 18, Guérin #36, ex coll. Stinnes, Philadelphia Museum of Art.

15. MUNCH, EDVARD (Norwegian, 1863–1944) THE MODEL (STUDY FOR PUBERTY), 1894, lithograph, 15¾ x 10⅞, Schiefler #8, National Gallery of Art, Lessing J. Rosenwald Collection.

16. MUNCH, EDVARD (Norwegian, 1863–1944), MADONNA, 1895–1902, color lithograph, 23⅞ x 17⅜, Schiefler #33, Museum of Modern Art.

17. MUNCH, EDVARD (Norwegian, 1863–1944) WOMAN, 1895, drypoint & aquatint, 11⅜ x 13¼, Schiefler #21, Philadelphia Museum of Art.

18. MUNCH, EDVARD (Norwegian, 1863–1944) THE DEATH OF MARAT, 1906, color lithograph, 17¼ x 13½, Schiefler #258, National Gallery of Art, Lessing J. Rosenwald Collection.

19. MUNCH, EDVARD (Norwegian, 1863–1944) SICK CHILD, 1894, drypoint, 15⅜ x 11½, Schiefler #7, National Gallery of Art, Lessing J. Rosenwald Collection.

20. MUNCH, EDVARD (Norwegian, 1863–1944) TWO PEOPLE (THE LONELY ONES), 1895, drypoint, 6⅛ x 8⅜, Schiefler #20, National Gallery of Art, Lessing J. Rosenwald Collection.

21. MUNCH, EDVARD, (Norwegian, 1863–1944) THE CRY (GESCHREI) 1895, lithograph, 13⅞ x 10, Schiefler #32, National Gallery of Art, Lessing J. Rosenwald Collection.

22. MUNCH, EDVARD (Norwegian, 1863–1944) DESPAIR, 1908, lithograph, 16½ x 13, Schiefler #325, Philadelphia Museum of Art.

23. MUNCH, EDVARD (Norwegian, 1863–1944) THE RAG PICKER (THE WANDERER), 1908–1909, woodcut, 13 x 8½, Schiefler #340, Municipal Art Museum, Oslo, Norway.

24. MUNCH, EDVARD (Norwegian, 1863–1944) THE LAST HOUR (SKULE IN A NUNNERY), 1919–1920, woodcut, 16¾ x 22⅝, Schiefler #491, Municipal Art Museum, Oslo, Norway.

25. KIRCHNER, ERNST LUDWIG (German, 1880–1938) GIRL DRYING HERSELF, 1908, drypoint, 12½ x 10¼, Schiefler #79, Eigendruck, Philadelphia Museum of Art.

26. HECKEL, ERICH (German, 1883–    ) GIRL RECLINING, 1910, drypoint, 5⅛ x 7½, Philadelphia Museum of Art.

27. NOLDE, EMIL (German, 1867–1956) NUDE, 1908, etching &
    aquatint, 18⅝ x 11¾, Schiefler #91, Philadelphia Museum
    of Art.

28. KIRCHNER, ERNST LUDWIG (German, 1880–1938) VARIÉTÉ
    (DREI AKROBATINNEN IN WEISSEN TRIKOT), 1916, woodcut,
    13⅝ x 13⅛, Schiefler #209, Eigendruck, ex coll. Kunstverein,
    Jena, Philadelphia Museum of Art.

29. KIRCHNER, ERNST LUDWIG (German, 1880–1938) NUDES IN
    THE WOODS (SPIELENDE NACKTE KINDER), 1925, color litho-
    graph, 12⅞ x 11, Schiefler #437, Probedruck, Weyhe
    Gallery.

30. KIRCHNER, ERNST LUDWIG (German, 1880–1938) PORTRAIT
    OF SCHAMES, 1917, woodcut, 21¼ x 9, Schiefler #281,
    Brooklyn Museum of Art.

31. KIRCHNER, ERNST LUDWIG (German, 1880–1938) PORTRAIT
    OF WILL GROHMANN, 1924, color woodcut, 21⅝ x 16⅛,
    Schiefler #524 iii, Eigendruck, New Art Center.

32. KIRCHNER, ERNST LUDWIG (German, 1880–1938) THREE
    PATHS, 1917, woodcut, 19⅝ x 13⅜, Schiefler #284, Chicago
    Art Institute.

33. KIRCHNER, ERNST LUDWIG (German, 1880–1938) MOUNTAIN
    LANDSCAPE NEAR GLARUS, ca. 1933, woodcut, 13½ x 19½,
    not in Schiefler, Eigendruck, Philadelphia Museum of Art.

34. KIRCHNER, ERNST LUDWIG (German, 1880–1938) WORK AT
    TABLE, 1923, woodcut, 15 x 27¼, Schiefler #476, Eigendruck,
    National Gallery of Art, Lessing J. Rosenwald Collection.

35. KIRCHNER, ERNST LUDWIG (German, 1880–1938) COWS
    (AUSGELASSENE KÜHE), ca. 1933, color woodcut, 13¾ x 19⅞,
    not in Schiefler, Detroit Institute of Arts.

36. KIRCHNER, ERNST LUDWIG (German, 1880–1938) PORTRAIT
    OF HANS ARP, ca. 1933, woodcut, 13⅞ x 12½, not in Schie-
    fler, Philadelphia Museum of Art.

37. KLEE, PAUL (Swiss, 1879–1940) OLD MAN RECKONING,
    1929, etching, 11¾ x 9⅜, Soby #38, National Gallery of
    Art, Lessing J. Rosenwald Collection.

38. HECKEL, ERICH (German, 1883–    ) YOUNG GIRL WITH
    FLOWING HAIR, 1907, lithograph, 13 x 10¾, Philadelphia
    Museum of Art.

39. HECKEL, ERICH (German, 1883–    ) SELF PORTRAIT, 1919,
    color woodcut, 18¼ x 12¾, National Gallery of Art, Lessing
    J. Rosenwald Collection.

40. HECKEL, ERICH (German, 1883–    ) SNOWSTORM (SCHNEE-
    TREIBEN), 1914, woodcut, 17 x 11⅜, Philadelphia Museum of
    Art.

41. HECKEL, ERICH (German, 1883–    ) GIRL BY THE SEA
    (MÄDCHEN AM MEER), 1918, woodcut, 18 x 12¾, Philadel-
    phia Museum of Art.

42. KIRCHNER, ERNST LUDWIG (German, 1880–1938) THE MODEL, 1924, drypoint, 11¾ x 9⅞, Schiefler #475 ii, ex coll. Dresden Kupferstichkabinett, Philadelphia Museum of Art.

43. HECKEL, ERICH (German, 1883–     ) FJORD LANDSCAPE, 1924, drypoint, 10⅛ x 13⅞, Detroit Institute of Arts.

44. SCHMIDT-ROTTLUFF, KARL (German, 1884–     ) WOMAN, 1914, lithograph, 11¼ x 7⅞, Schapire #93, Philadelphia Museum of Art.

45. SCHMIDT-ROTTLUFF, KARL (German, 1884–     ) WOMAN WITH LOOSE HAIR, 1913, woodcut, 14¼ x 11¾, Schapire #123, National Gallery of Art, Lessing J. Rosenwald Collection.

46. SCHMIDT-ROTTLUFF, KARL (German, 1884–     ) CATS, 1914, woodcut, 15¼ x 19½, Schapire #148, National Gallery of Art, Lessing J. Rosenwald Collection.

47. SCHMIDT-ROTTLUFF, KARL (German, 1884–     ) WAY TO EMMAUS, 1918, woodcut, 15½ x 19½, Schapire #212, Philadelphia Museum of Art.

48. SCHMIDT-ROTTLUFF, KARL (German, 1884–     ) PROPH-ETESS, 1919, woodcut, 19⅝ x 15½, Schapire #258, Philadelphia Museum of Art.

49. SCHMIDT-ROTTLUFF, KARL (German, 1884–     ) AFTER THE CATCH, 1923, lithograph, 16¼ x 23, Schapire #102, National Gallery of Art, Lessing J. Rosenwald Collection.

50. SCHMIDT-ROTTLUFF, KARL (German, 1884–     ) WINTER, DUNES AND BREAKWATER, 1917, color woodcut, 11¼ x 13¼, Schapire #195, Philadelphia Museum of Art.

51. SCHMIDT-ROTTLUFF, KARL (German, 1884–     ) WOMAN IN THE DUNES, 1914, woodcut, 15½ x 19¾, Schapire #143, Philadelphia Museum of Art.

52. SCHMIDT-ROTTLUFF, KARL (German, 1884–     ) MOON-LIGHT, 1924, woodcut, 15½ x 19⅝, not in Schapire, ex coll. Stinnes, Philadelphia Museum of Art.

53. NOLDE, EMIL (German, 1867–1956) PROPHET, 1912, wood-cut, 12¾ x 8⅞, Schiefler #110, National Gallery of Art, Lessing J. Rosenwald Collection.

54. NOLDE, EMIL (German, 1867–1956) JESTRI, 1917, woodcut, 12 x 9⅜, Schiefler #149, Philadelphia Museum of Art.

55. NOLDE, EMIL (German, 1867–1956) DANCER, 1922, etching & aquatint, 12½ x 5⅝, Schiefler #211, Philadelphia Museum of Art.

56. NOLDE, EMIL (German, 1867–1956) THREE KINGS, 1913, color lithograph, 25¼ x 20½, Schiefler #49, Probedruck, National Gallery of Art, Lessing J. Rosenwald Collection.

57. PECHSTEIN, MAX (German, 1881–1955) THE CONVALESCENT,

woodcut, 15¾ x 10¼, National Gallery of Art, Lessing J. Rosenwald Collection.

58. PECHSTEIN, MAX (German, 1881–1955) PORTRAIT OF DR. PAUL FECHTER, 1921, drypoint, 15¼ x 12¼, National Gallery of Art, Lessing J. Rosenwald Collection.

59. MÜLLER, OTTO (German, 1874–1930) THREE FIGURES IN LANDSCAPE, ca. 1918, lithograph, 12⅝ x 9⅝, Philadelphia Museum of Art.

60. MÜLLER, OTTO (German, 1874–1930) GIRL AMONG THE REEDS, 1919, woodcut, 11 x 14¾, National Gallery of Art, Lessing J. Rosenwald Collection.

61. MARCKS, GERHARD (German, 1889–    ) PEASANT WITH COW (KUHBAUER), 1924, woodcut, 11¾ x 10, Philadelphia Museum of Art.

62. KANDINSKY, WASSILY, (Russian, 1866–1944) COMPOSITION, 1911, woodcut, 6¼ x 8⅜, from Klänge, Philadelphia Museum of Art.

63. MARC, FRANZ (German, 1880–1916) ANNUNCIATION, 1912, woodcut, 7⅞ x 10¼, signed and numbered 11, Philadelphia Museum of Art.

64. MARC, FRANZ (German, 1880–1916) TIGERS, 1912, woodcut, 7⅞ x 9½, Brooklyn Museum of Art.

65. MARC, FRANZ (German, 1880–1916) GENESIS II, 1914, color woodcut, 9⅜ x 7¾, Philadelphia Museum of Art.

66. MACKE, AUGUST (German, 1887–1914) GREETING, 1912, linoleum cut, 9½ x 7⅝, Philadelphia Museum of Art.

67. CAMPENDONK, HEINRICH (German, 1889–    ) SEATED WOMAN WITH ANIMALS, 1916, woodcut, 14⅞ x 11½, University of Michigan Art Gallery.

68. MARC, FRANZ (German, 1880–1916) RIDING SCHOOL, 1913, woodcut, 10½ x 11⅝, Fogg Art Museum.

69. KLEE, PAUL (Swiss, 1879–1940) WITCH WITH COMB, 1922, lithograph, 12 x 8½, Soby #29, Philadelphia Museum of Art.

70. KLEE, PAUL (Swiss, 1879–1940) SAINT OF THE INNER LIGHT, 1921, color lithograph, 12¼ x 7, Soby #24, Philadelphia Museum of Art.

71. FEININGER, LYONEL (American, 1871–1956) MELLINGEN, 1919, woodcut, 12 x 10, Feininger list #1965, Philadelphia Museum of Art.

72. FEININGER, LYONEL (American, 1871–1956) THE CITY, ca. 1920, woodcut, 6⅞ x 9½, National Gallery of Art, Lessing J. Rosenwald Collection.

73. KOKOSCHKA, OSKAR (Austrian, 1886–    ) THE WOMAN STRIDES OVER THE BIER OF THE DEAD MAN, 1913, lithograph,

12¼ x 10, Arntz #33, **from the set** Der Gefesselte Kolumbus, **Philadelphia Museum of Art.**

74. **KOKOSCHKA, OSKAR (Austrian, 1886–    ) HOPE LEADING THE WEAK ONE, 1914, lithograph, 15⅛ x 12⅜, Arntz #38, from the set** Bach Cantata, **Probedruck, Philadelphia Museum of Art.**

75. **KOKOSCHKA, OSKAR (Austrian, 1886–    ) CHRIST ON THE MOUNT OF OLIVES, 1916, lithograph, 11¼ x 12½, Arntz #54a, Philadelphia Museum of Art.**

76. **KOKOSCHKA, OSKAR (Austrian, 1886–    ) ESTHER, 1920, lithograph, 21 x 17, Arntz #116, from the set** Daughters of the Covenant, **National Gallery of Art, Lessing J. Rosenwald Collection.**

77. **HOFER, KARL (German, 1878–1955) NOVITIATE, 1922, lithograph, 17½ x 13, National Gallery of Art, Lessing J. Rosenwald Collection.**

78. **HOFER, KARL (German, 1878–1955) GIRL AND MOON, 1923, lithograph, 11¼ x 7½, from the set** Zenana, **Philadelphia Museum of Art.**

79. **HOFER, KARL (German, 1878–1955) SOKOTRA, ca. 1923, drypoint, 9⅝ x 13³⁄₁₆, University of Michigan Art Gallery.**

80. **CORINTH, LOVIS (German, 1858–1925) SELF PORTRAIT, 1920, lithograph, 13 x 10½, National Gallery of Art, Lessing J. Rosenwald Collection.**

81. **MATARÉ, EWALD (German, 1887–    ) COWS GRAZING AT NIGHT (NÄCHTLICHE WIESE), ca. 1932, color woodcut, 7½ x 17½, Philadelphia Museum of Art.**

82. **ROHLFS, CHRISTIAN (German, 1849–1938) PRISONER, 1918, woodcut, 24½ x 19¼, Vogt #107, Albion College Gallery of Art.**

83. **BARLACH, ERNST (German, 1870–1938) TO JOY, 1927, woodcut, 10 x 14, from Schiller's** Ode to Joy, **Mr. & Mrs. Erich Cohn.**

84. **BARLACH, ERNST (German, 1870–1938) CHRIST ON THE MOUNT OF OLIVES, 1920, woodcut, 8 x 10, National Gallery of Art, Lessing J. Rosenwald Collection.**

85. **BARLACH, ERNST (German, 1870–1938) REBELLION (THE PROPHET ELIAS), 1922, lithograph, 20½ x 16¾, from the set** Die Augestossenen, **National Gallery of Art, Lessing J. Rosenwald Collection.**

86. **BARLACH, ERNST (German, 1870–1938) JUDGMENT DAY, 1932, lithograph, 12⅜ x 17, Philadelphia Museum of Art.**

87. **KOLLWITZ, KÄTHE (German, 1867–1945) THE VOLUNTEERS, 1922, woodcut, 13⅜ x 19¾, Klipstein #178, Philadelphia Museum of Art.**

88. KOLLWITZ, KÄTHE (German, 1867–1945) DEATH WITH CHILD IN LAP, 1921, woodcut, 9⅜ x 11¼, Klipstein #151, Philadelphia Museum of Art.

89. KOLLWITZ, KÄTHE (German, 1867–1945) DEATH SEIZES A WOMAN, 1934–1935, lithograph, 20 x 14, Klipstein #259, Mr. & Mrs. Erich Cohn.

90. LEHMBRUCK, WILHELM (German, 1881–1919) THE LONELY WOMAN (DAS EINSAME WEIB), 1913, etching, 19¼ x 9¾, signed, University of Michigan Art Gallery.

91. LEHMBRUCK, WILHELM (German, 1881–1919) FOUR WOMEN, 1913, etching, 11¾ x 7¾, signed, National Gallery of Art, Lessing J. Rosenwald Collection.

92. MARCKS, GERHARD (German, 1889–      ) CATS, 1921, woodcut, 9½ x 15¼, Philadelphia Museum of Art.

93. MARCKS, GERHARD (German, 1889–      ) POLISH MOTHER (POLENMUTTER), 1922, woodcut, 8½ x 8¼, Philadelphia Museum of Art.

94. MARCKS, GERHARD (German, 1889–      ) DRUMMERS, 1921, woodcut, 12⅛ x 6⅛, Detroit Institute of Arts.

95. MARCKS, GERHARD (German, 1889–      ) ANGEL OF COLOGNE, 1946, woodcut, 21 x 7⅛, Philadelphia Museum of Art.

96. LEHMBRUCK, WILHELM (German, 1881–1919) MACBETH, 1918, etching, 15⅜ x 11½, National Gallery of Art, Lessing J. Rosenwald Collection.

97. MEIDNER, LUDWIG (German, 1884–      ) PROPHET, ca. 1918, lithograph, 16 x 12½, Philadelphia Museum of Art.

98. STEINHARDT, JAKOB (Israeli, 1887–      ) CAIN, 1912, etching & drypoint, 4¾ x 5¾, Philadelphia Museum of Art.

99. HECKEL, ERICH (German, 1883–      ) INSANE PEOPLE EATING (IRRE BEIM ESSEN), 1914, drypoint, 7½ x 5⅝, Philadelphia Museum of Art.

100. KUBIN, ALFRED (German, 1877–      ) THE RETURN HOME (HEIMKEHR), ca. 1918, lithograph, 5¼ x 11⅝, Philadelphia Museum of Art.

101. GANGOLF, PAUL (German, XX century) ST. ANTHONY TORMENTED, ca. 1923, lithograph, 11⅜ x 9⅛, Philadelphia Museum of Art.

102. GROSZ, GEORGE (American, 1893–      ) SELF PORTRAIT FOR CHARLIE CHAPLIN, 1919, lithograph, 19½ x 13⅛, Philadelphia Museum of Art.

103. GROSZ, GEORGE (American, 1893–      ) CIRCUS, lithograph, 11¼ x 10, National Gallery of Art, Lessing J. Rosenwald Collection.

104. GROSZ, GEORGE (American, 1893–      ) SUBURB, 1917, lithograph, 11½ x 9, Philadelphia Museum of Art.

105. **GROSZ, GEORGE (American, 1893–     ) WORKERS, 1921, lithograph, 12 x 16, from** Im Schatten, **ex coll. Stinnes, Philadelphia Museum of Art.**

106. **MASEREEL, FRANS (Belgian, 1889–     ) LE PARVENU, 1922, woodcut, 10½ x 7⅝, Philadelphia Museum of Art.**

107. **JANSEN, FRANZ M. (German, 1885–     ) 8 O'CLOCK, 1920, woodcut, 10¾ x 15¾, Philadelphia Museum of Art.**

108. **DIX, OTTO (German, 1891–     ) BABY, 1924, etching, 7⅝ x 5½, Philadelphia Museum of Art.**

109. **KLEINSCHMIDT, PAUL (German, 1883–1949) ODALISQUE, 1923, drypoint, 9⅝ x 12½, Philadelphia Museum of Art.**

110. **DIX, OTTO (German, 1891–     ) LENS BOMBED, 1924, etching & aquatint, 11¾ x 9½, Philadelphia Museum of Art.**

111. **BECKMANN, MAX (German, 1884–1950) OLD WOMAN, 1916, drypoint, 6¾ x 4⅞, Glaser #89, Probedruck, Philadelphia Museum of Art.**

112. **BECKMANN, MAX (German, 1884–1950) DECLARATION OF WAR, 1915, etching & drypoint, 7¾ x 9¾, Glaser #73, Modeldruck, Philadelphia Museum of Art.**

113. **BECKMANN, MAX (German, 1884–1950) NIGHT, 1919, lithograph, 21⅞ x 27⅝, Glaser #127, from the set** Hölle, **Museum of Modern Art.**

114. **BECKMANN, MAX (German, 1884–1950) DRESSING ROOM (GARDEROBE I), 1921, etching, 8⅛ x 12⅛, Glaser #167, Handprobedruck, Philadelphia Museum of Art.**

115. **BECKMANN, MAX (German, 1884–1950) KÖNIGINEN II, 1923, etching, 11¼ x 9½, not in Glaser, with dedication to Glaser, Philadelphia Museum of Art.**

116. **BECKMANN, MAX (German, 1884–1950) BEACH (STRAND), 1922, etching, 8⅜ x 12¾, Glaser #213, Philadelphia Museum of Art.**

117. **BECKMANN, MAX (German, 1884–1950) DREAM, 1924, drypoint, 7¾ x 15¾, not in Glaser, Philadelphia Museum of Art.**

118. **PICASSO, PABLO (Spanish, 1881–     ) REPAS FRUGAL, 1904, etching, 18⅛ x 14⅝, Geiser #2 IIa, ex coll. A. Stieglitz, Chicago Art Institute.**

119. **ROUAULT, GEORGES (French, 1871–     ) IN THE PRESS THE GRAPES WERE TRODDEN, 1922, mixed intaglio, 15⅝ x 19¼, from** Miserere, **Philadelphia Museum of Art.**

120. **CHAGALL, MARC (Russian, 1889–     ) THE GRANDFATHERS, 1923, drypoint, 10⅞ x 8⅜, Philadelphia Museum of Art.**

121. **WEBER, MAX (American, 1881–     ) MOTHER AND CHILD, 1918, woodcut, 4½ x 2, Philadelphia Museum of Art.**

122. **MARIN, JOHN (American, 1870–1953) BROOKLYN BRIDGE, 1913, etching, 6⅞ x 8⅞, Philadelphia Museum of Art.**

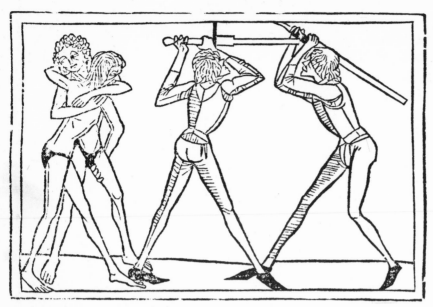

**1. German School (XV century)**

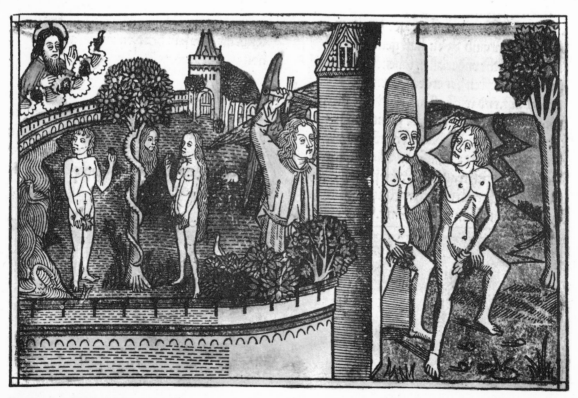

**2. German School (XV century)**

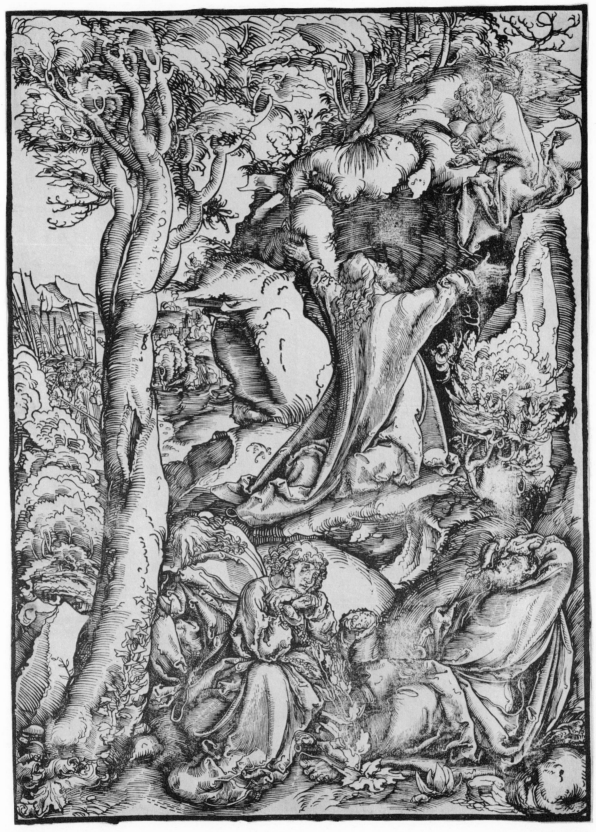

**3. Cranach**

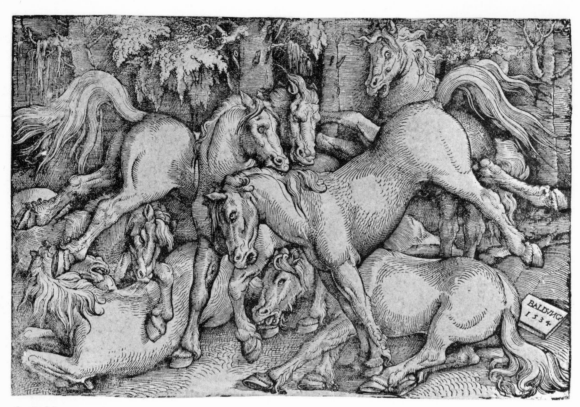

4. Baldung

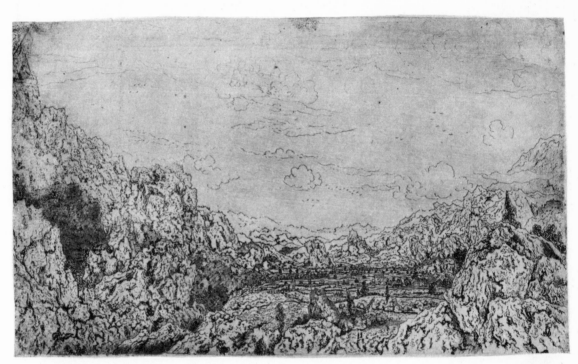

5. Seghers

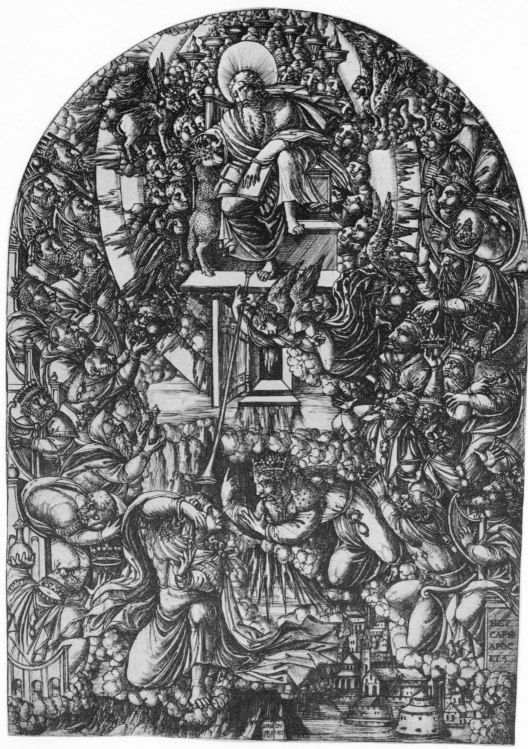

6. Duvet

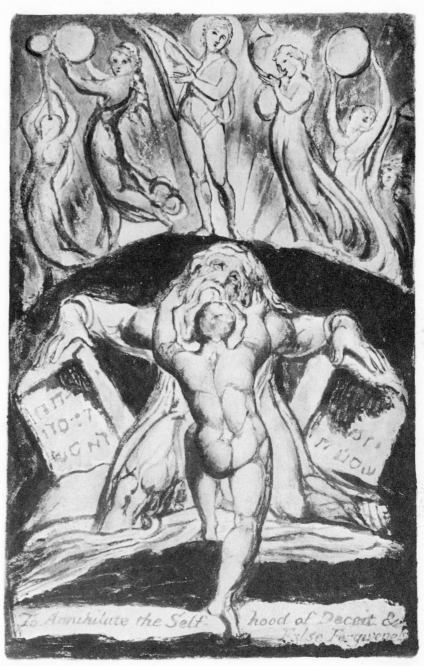

7. Blake

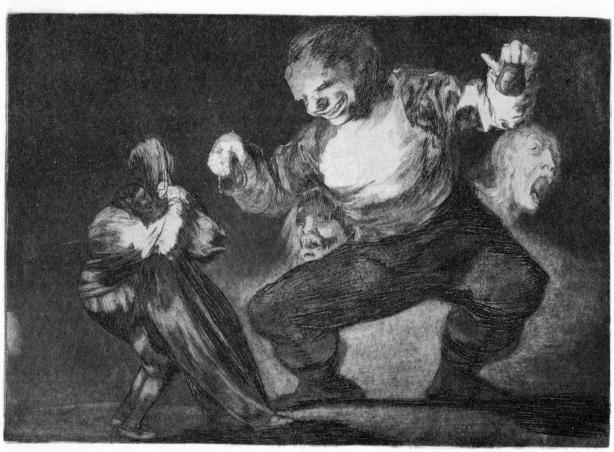

8. Goya

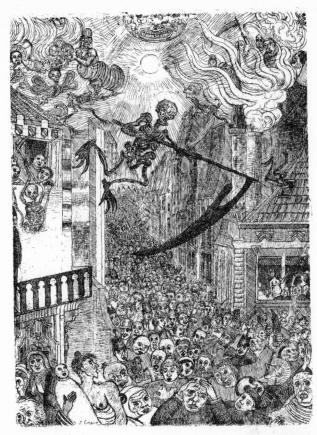

**9. Ensor**

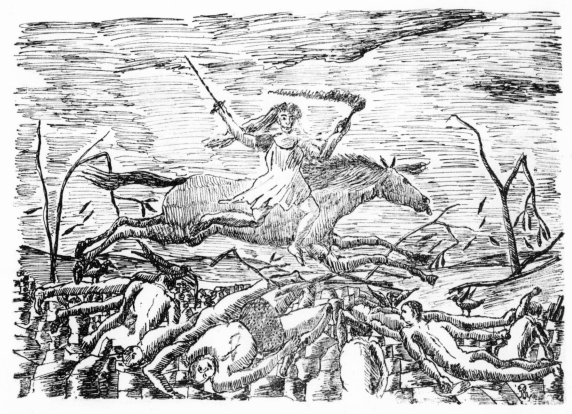

**10. Rousseau**

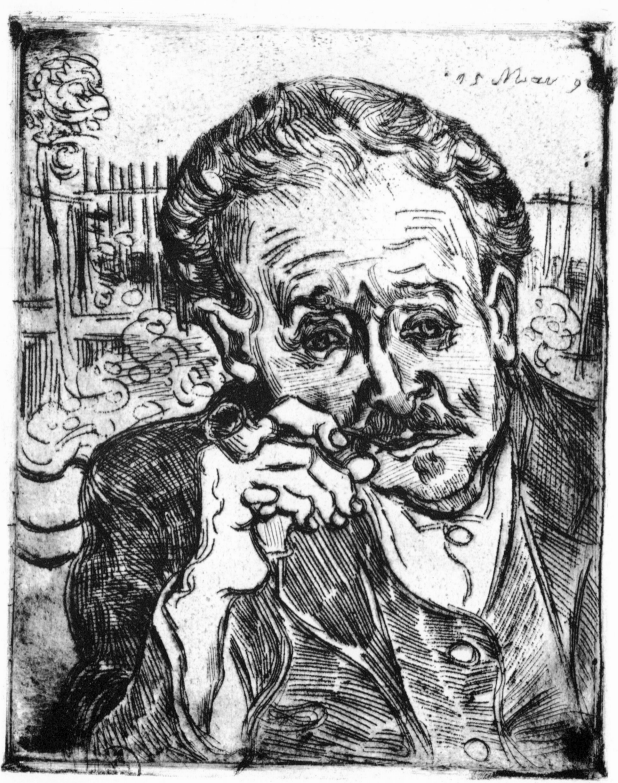

**11. Van Gogh**

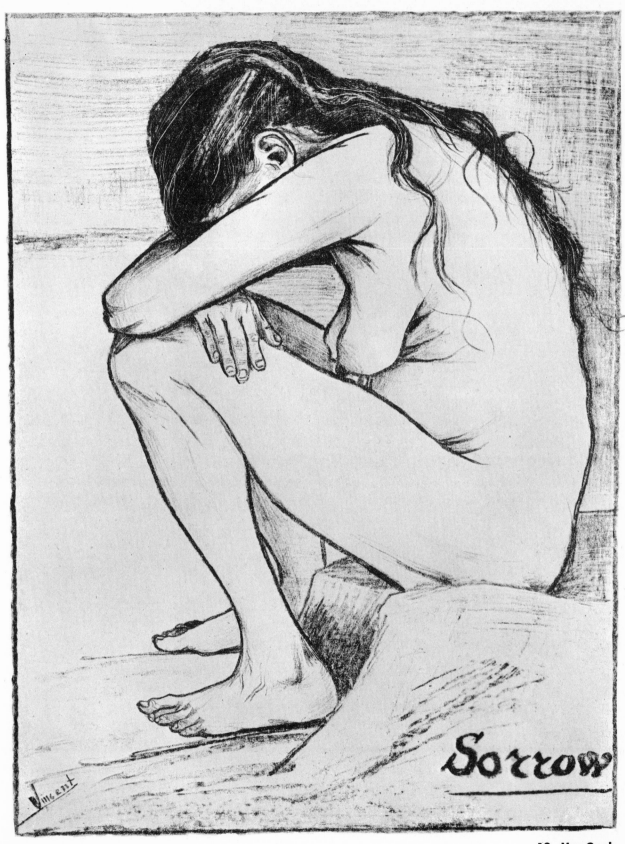

12. Van Gogh

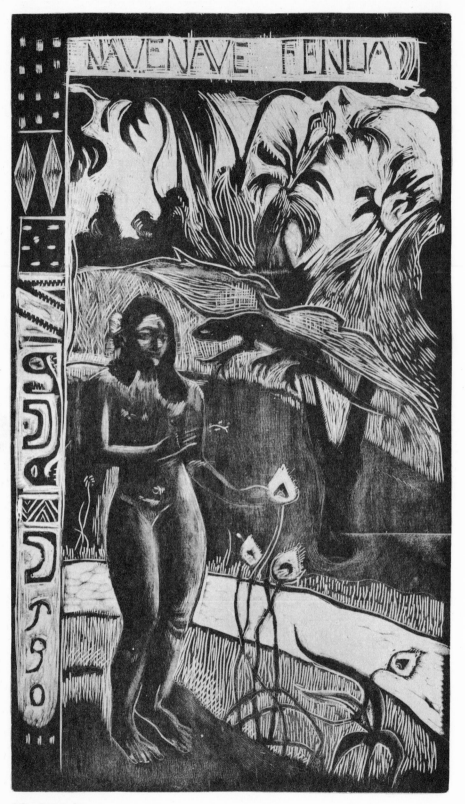

13. Gauguin

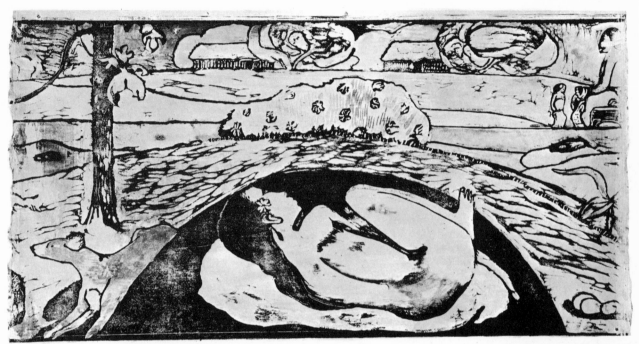

14. Gauguin

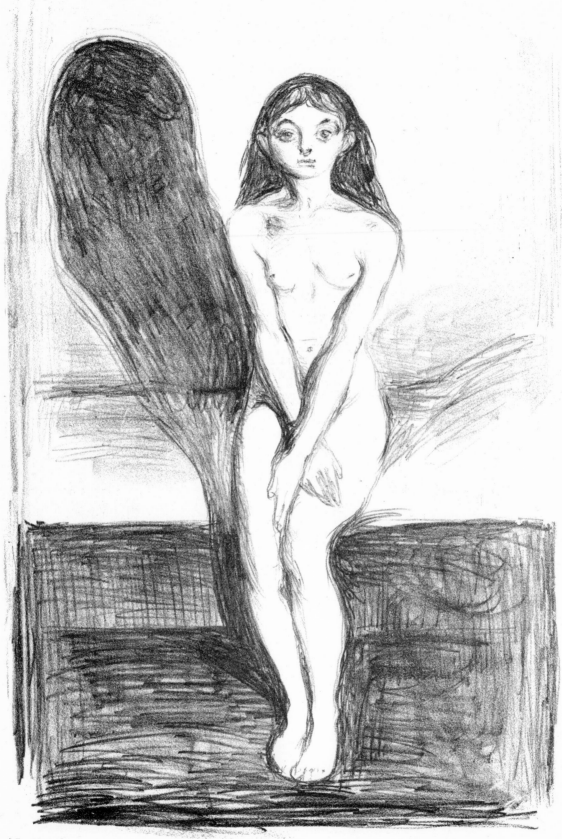

15. Munch

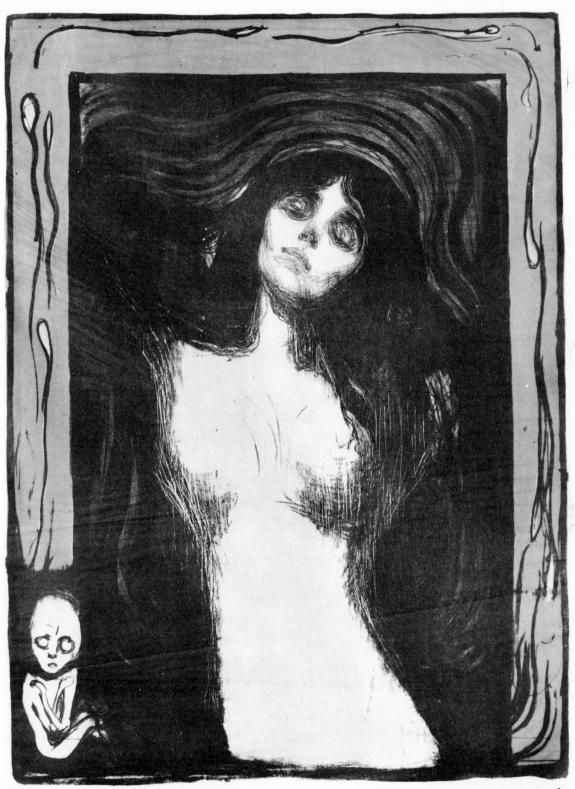

16. Munch

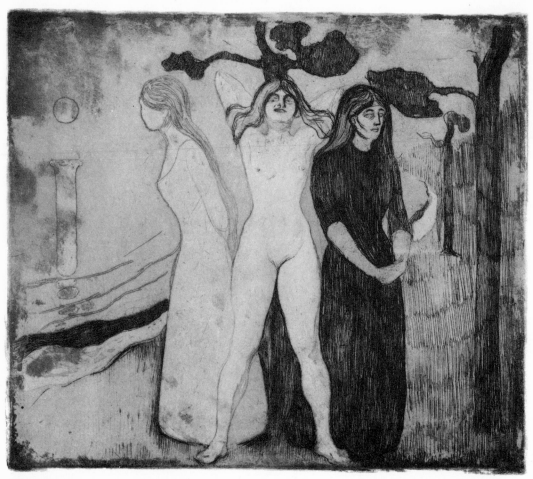

17. Munch

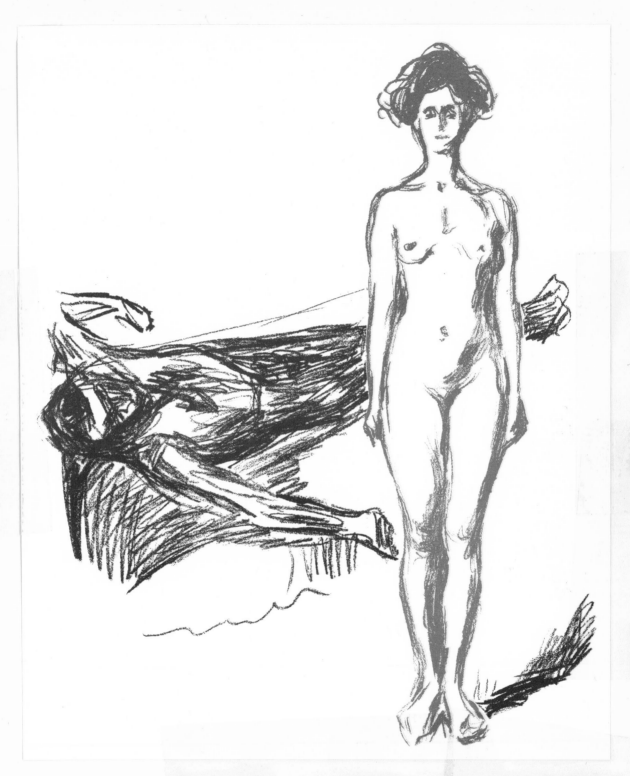

18. Munch

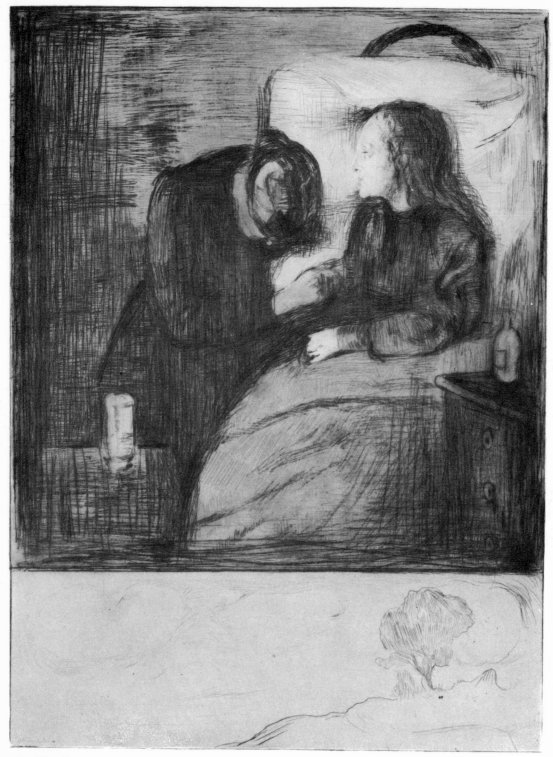

**19. Munch**

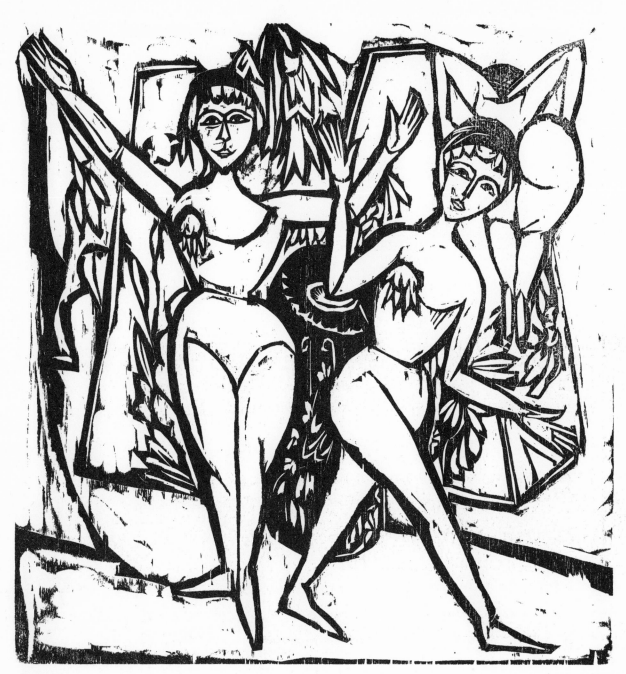

28. Kirchner

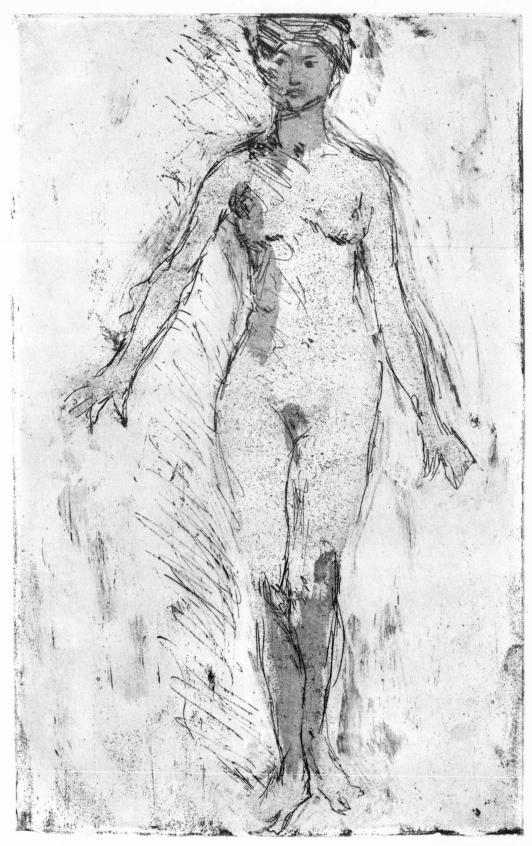

**27. Nolde**

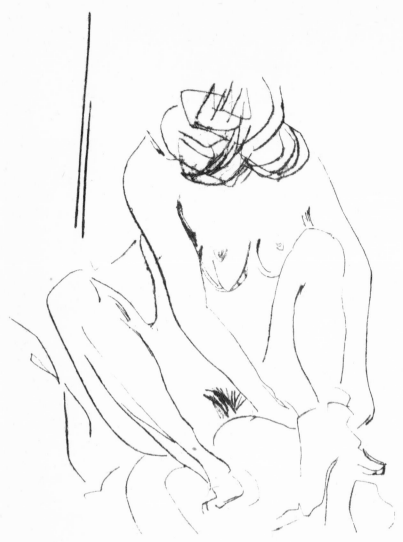

**25. Kirchner**

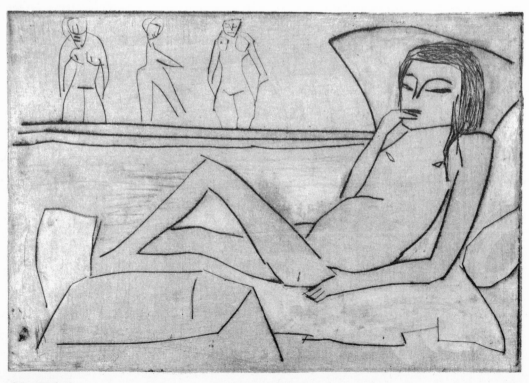

**26. Heckel**

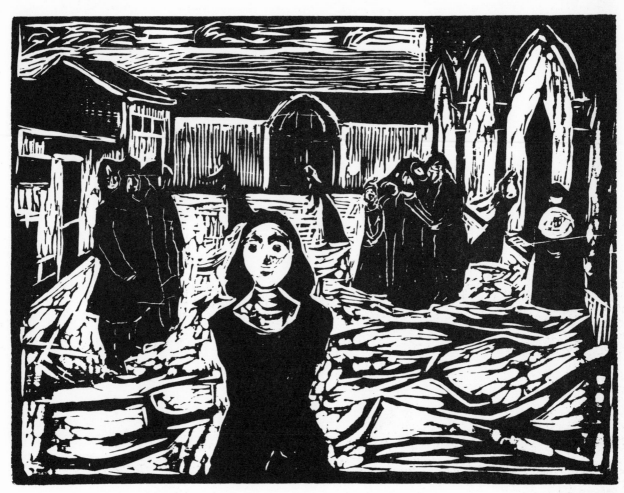

24. Munch

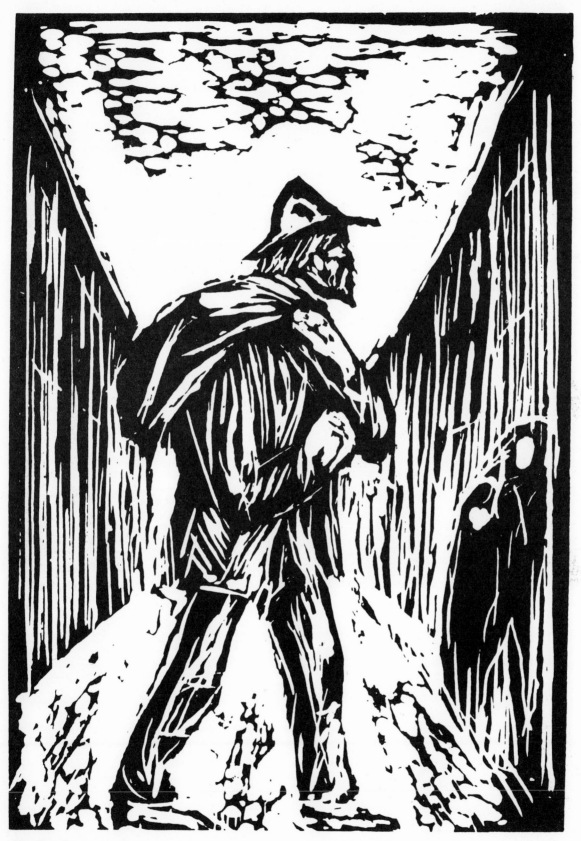

23. Munch

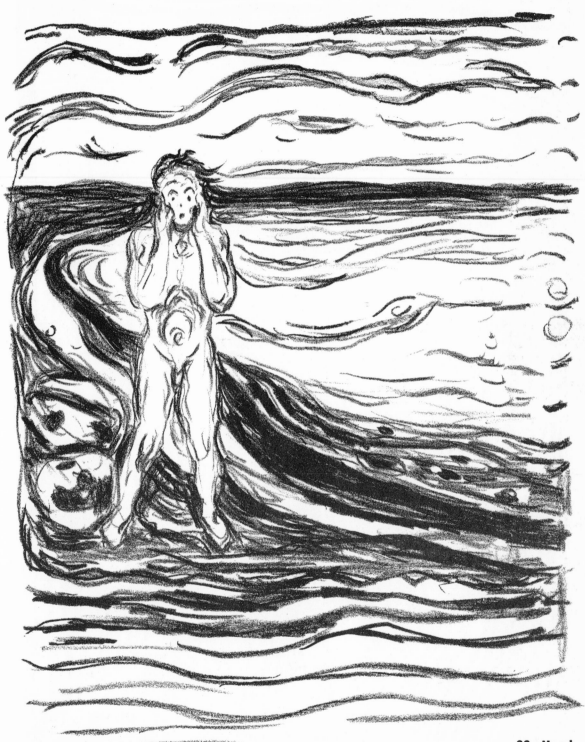

22. Munch

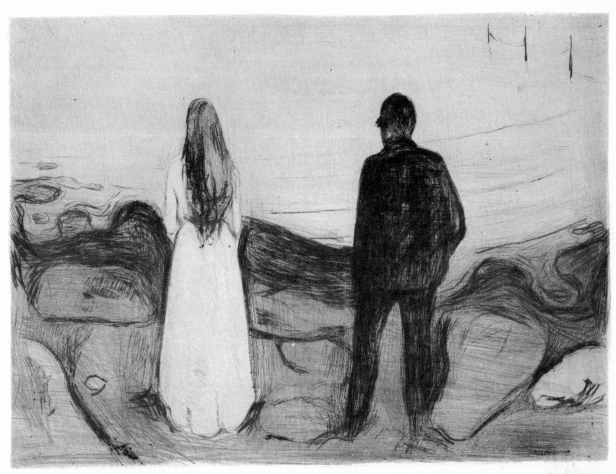

20. Munch

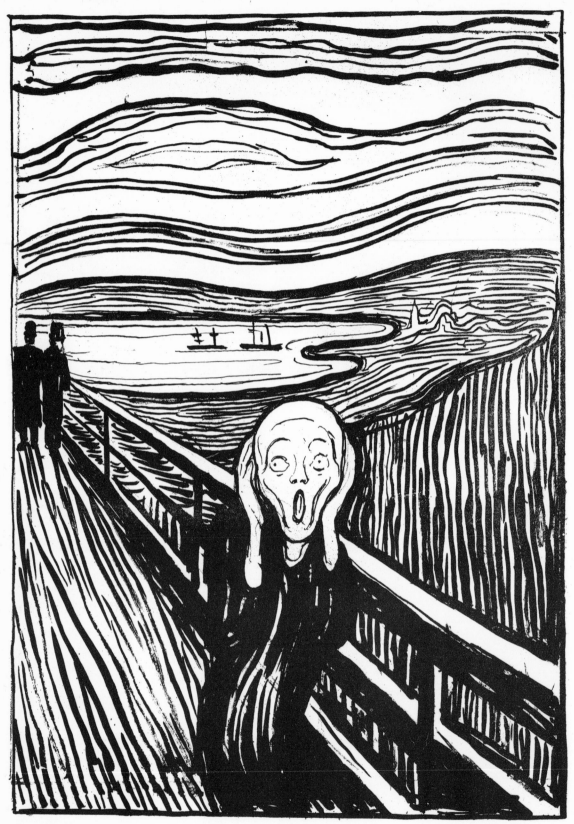

**21. Munch**

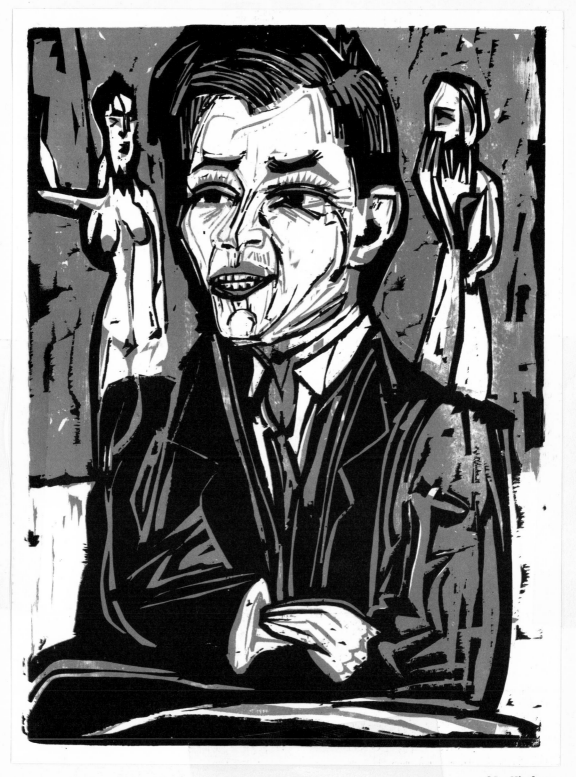

31. Kirchner

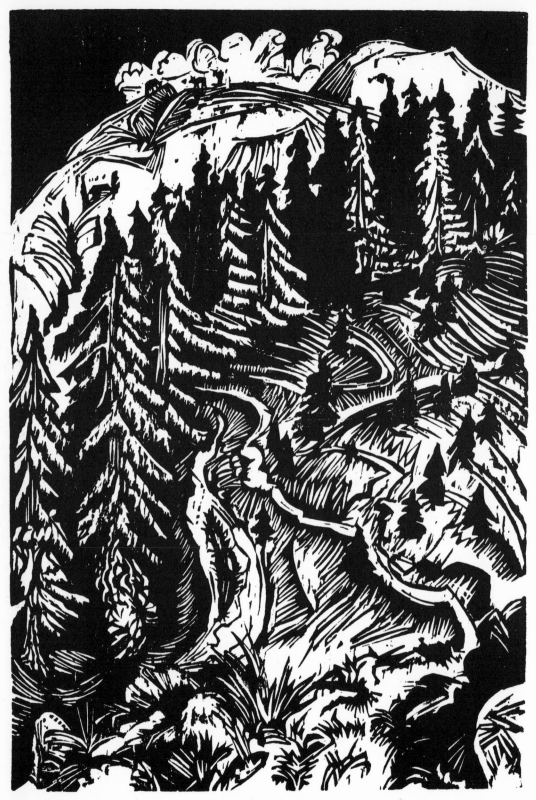

32. Kirchner

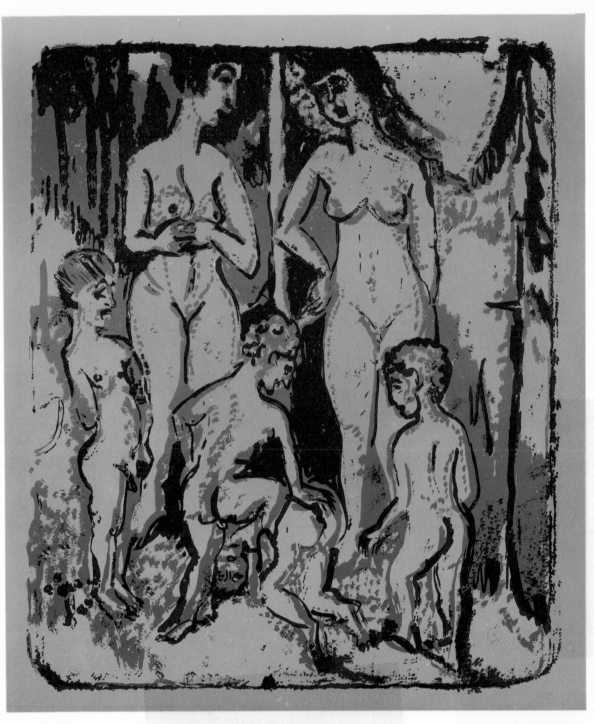

**29. Kirchner**

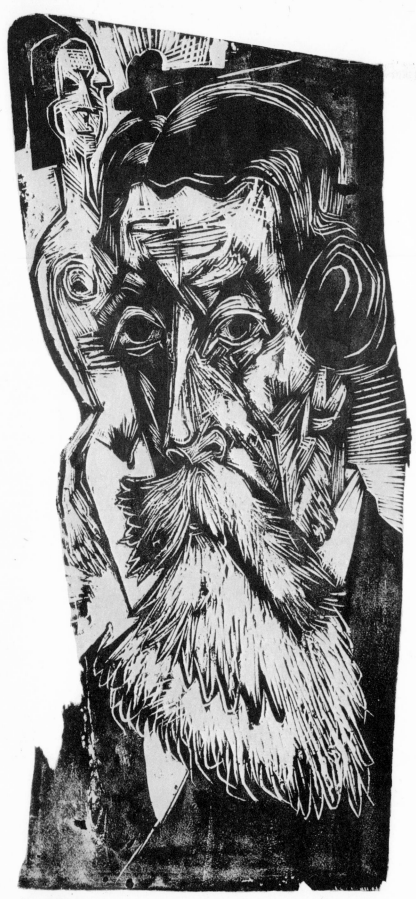

30. Kirchner

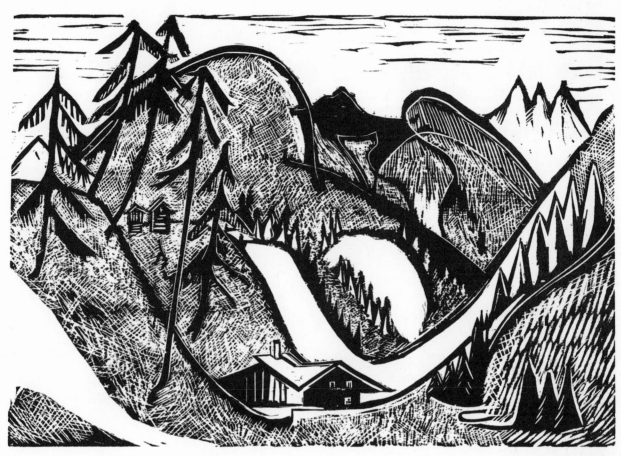

33. Kirchner

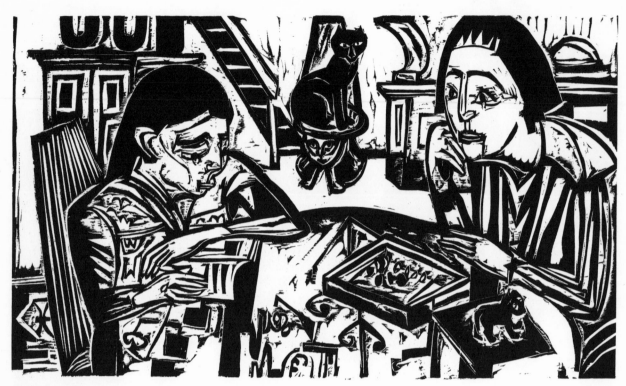

34. Kirchner

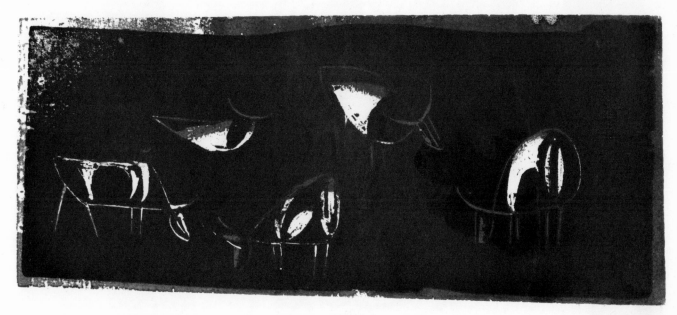

35. Kirchner

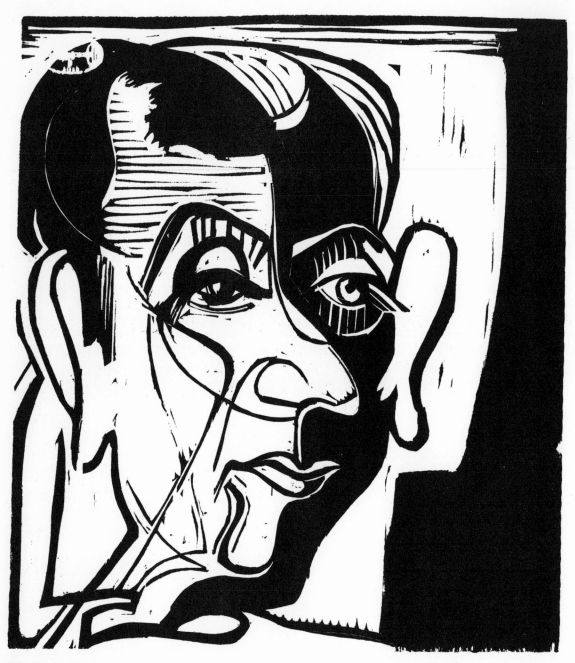

**36. Kirchner**

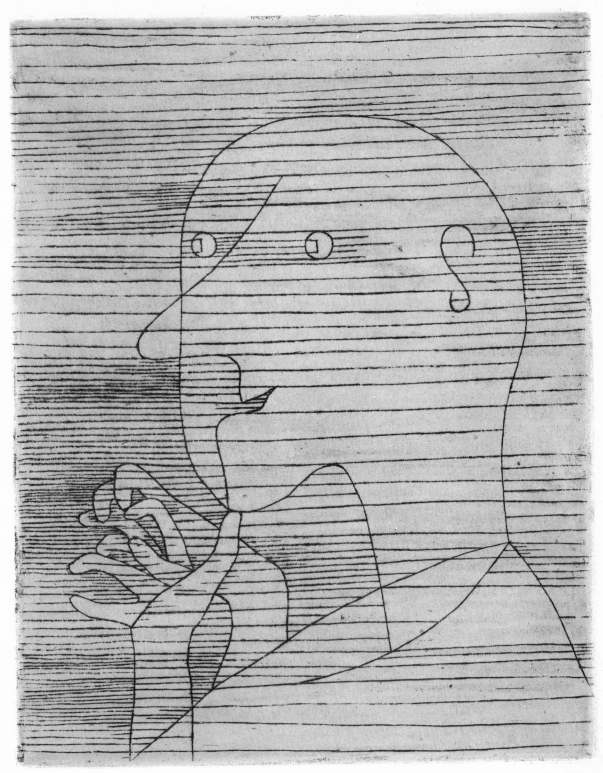

37. Klee

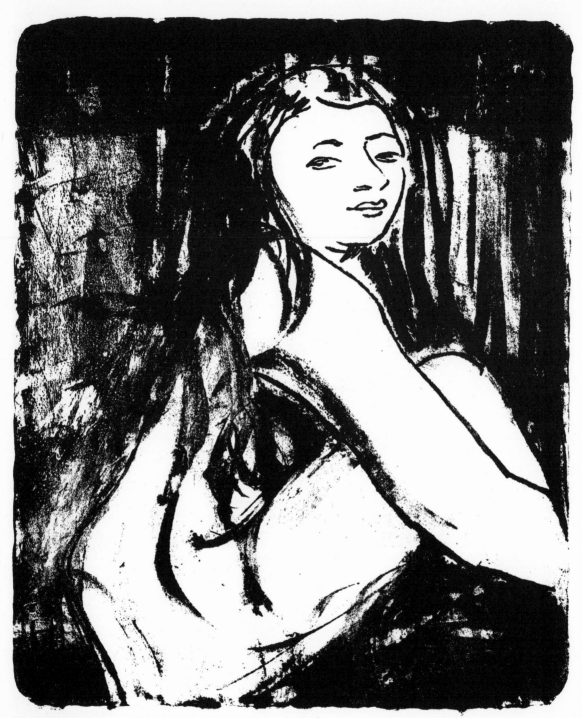

38. Heckel

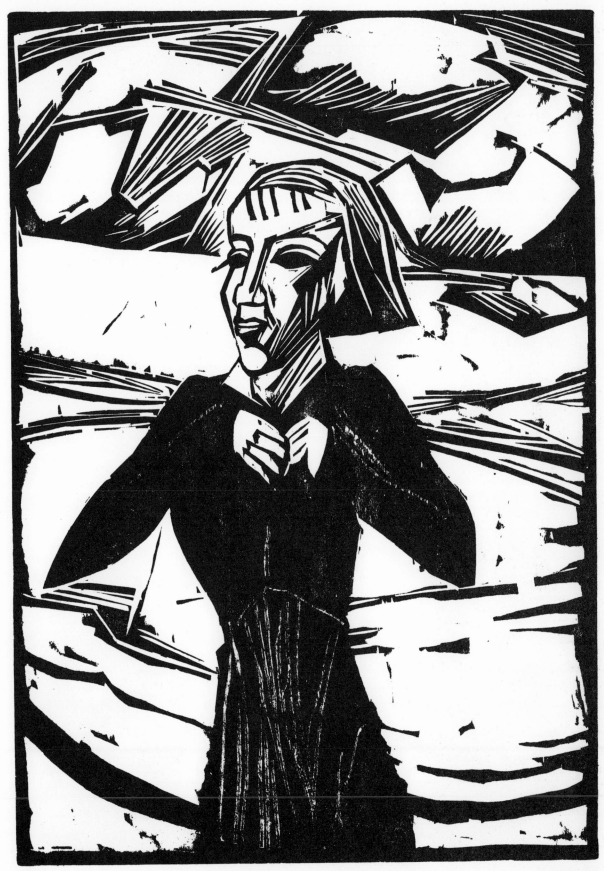

41. Heckel

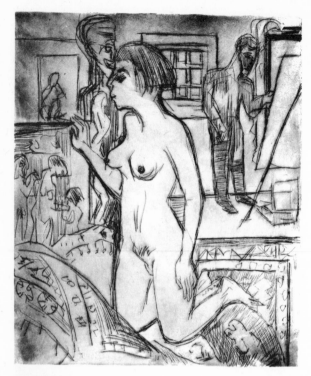

**42. Kirchner**

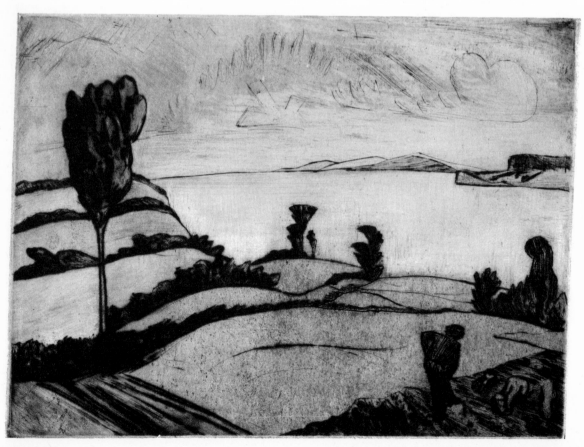

**43. Heckel**

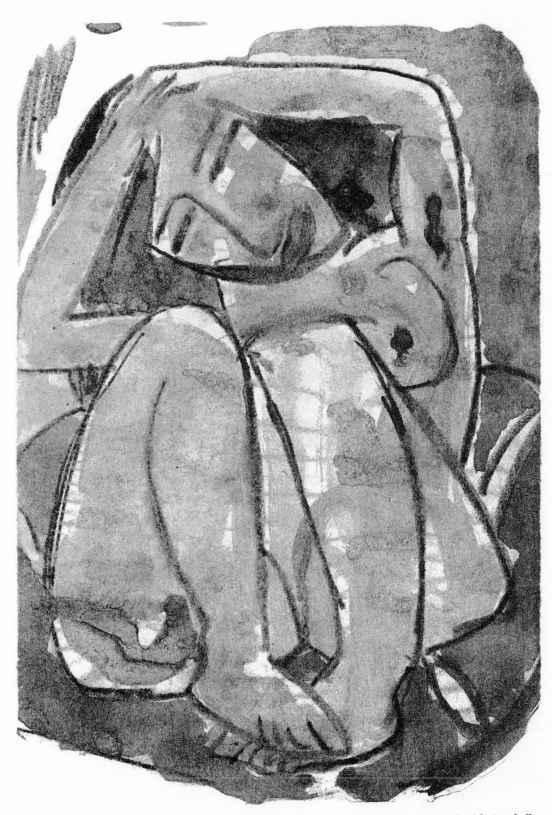

**44. Schmidt-Rottluff**

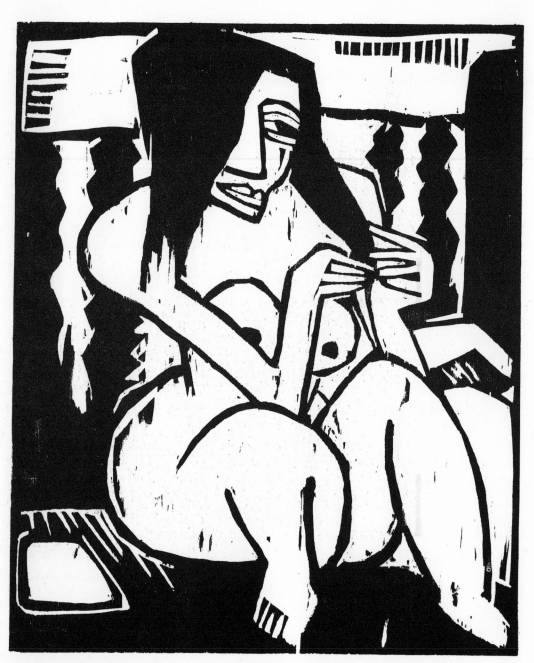

45. Schmidt-Rottluff

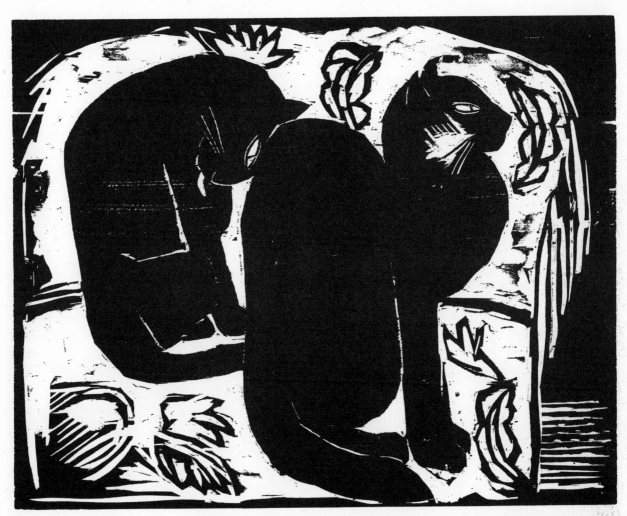

46. Schmidt-Rottluff

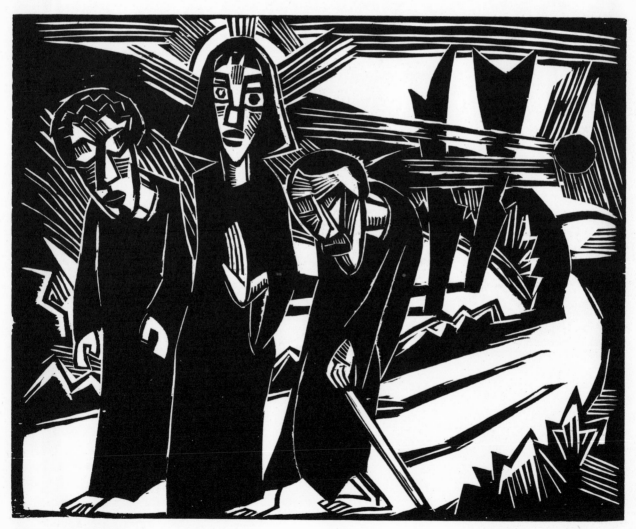

**47. Schmidt-Rottluff**

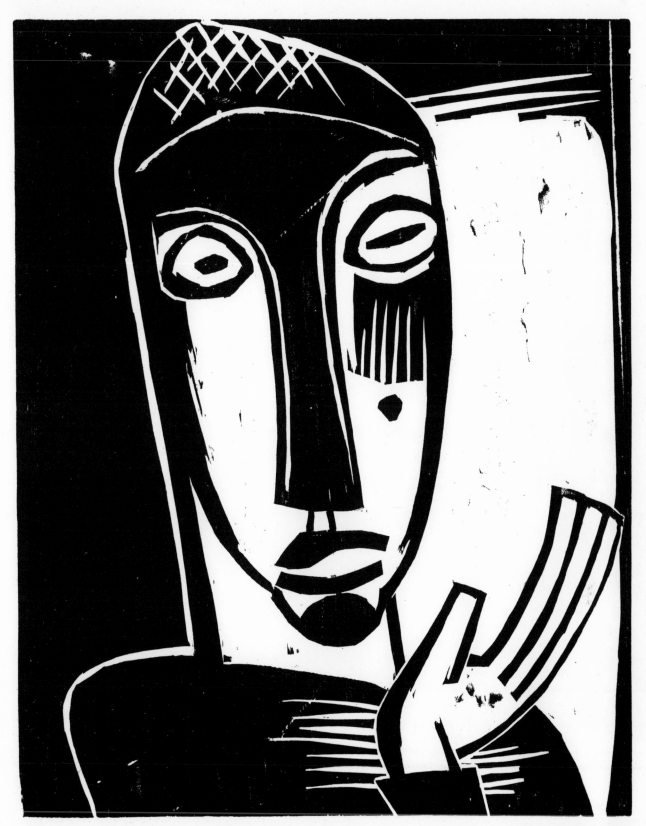

48. Schmidt-Rottluff

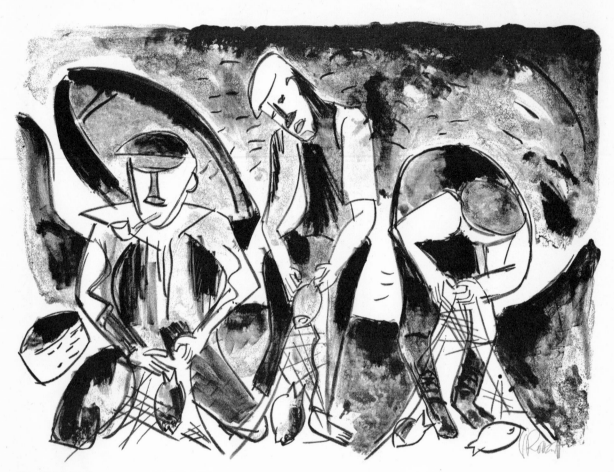

49. Schmidt-Rottluff

50. **Schmidt-Rottluff**

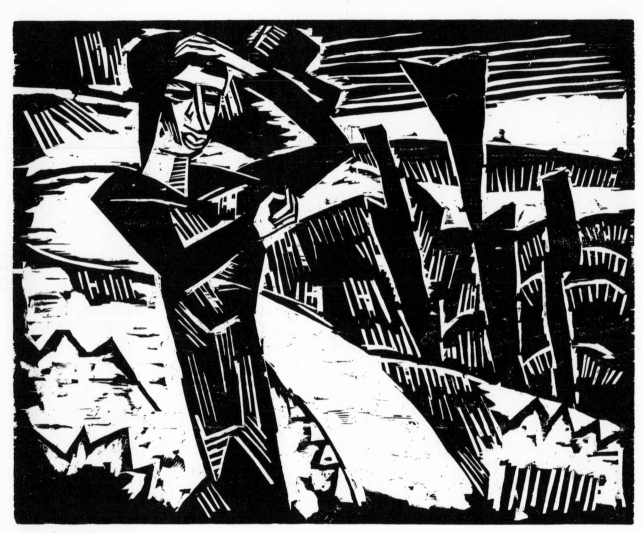

51. Schmidt-Rottluff

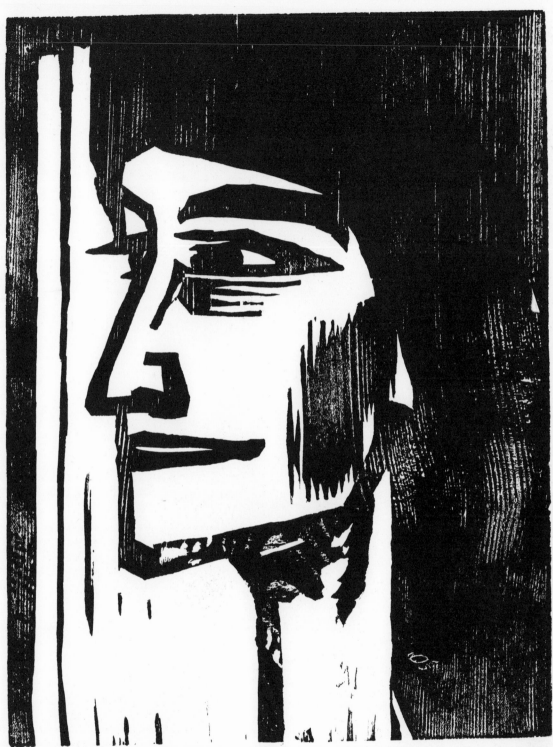

**54. Nolde**

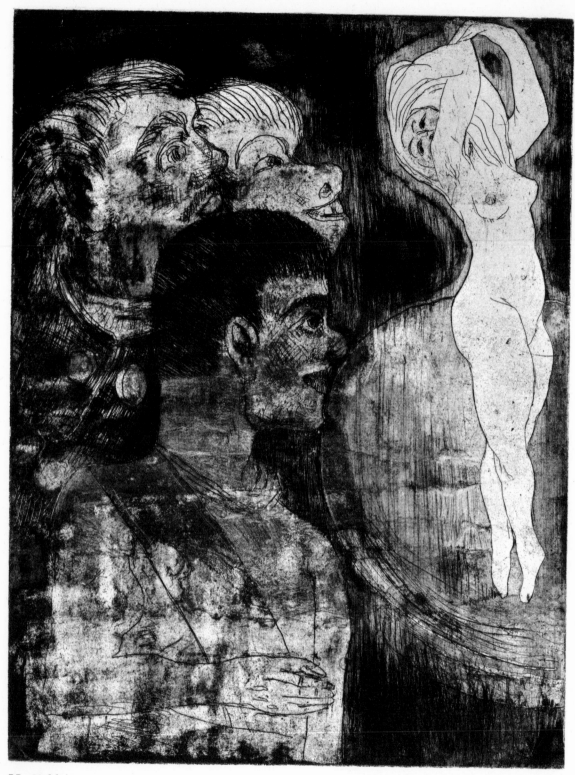

**55. Nolde**

56. Nolde

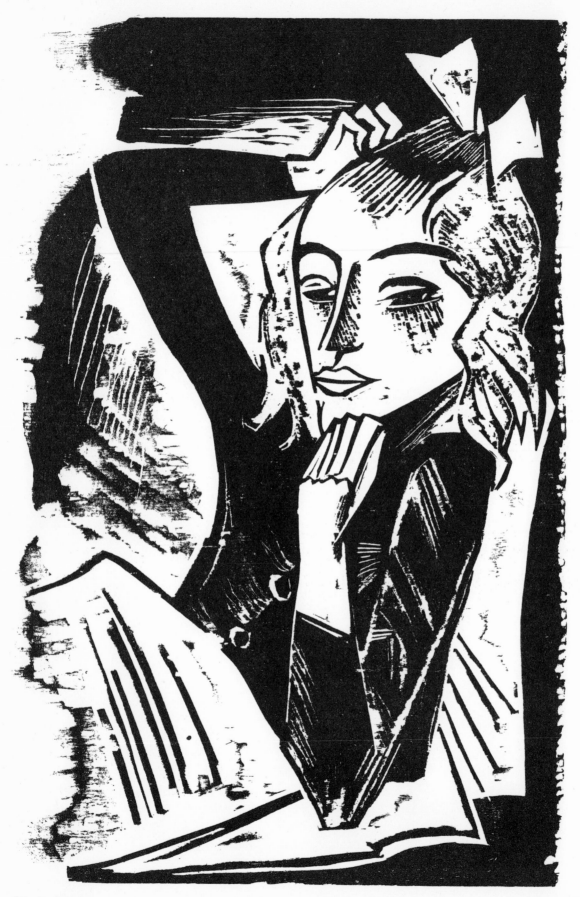

**57. Pechstein**

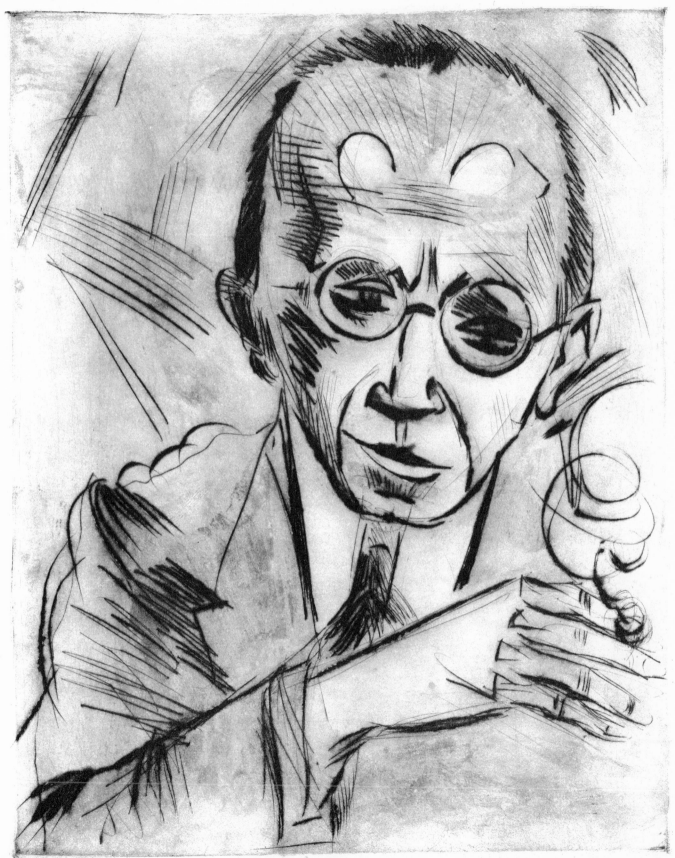

**58. Pechstein**

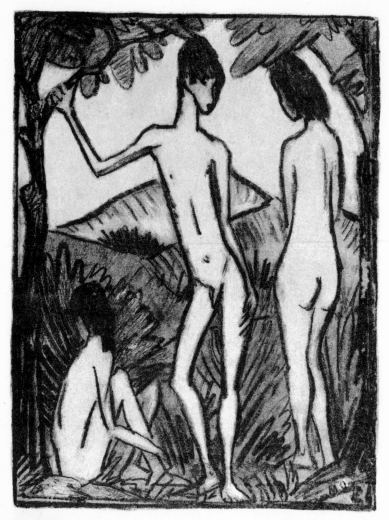

59. Müller

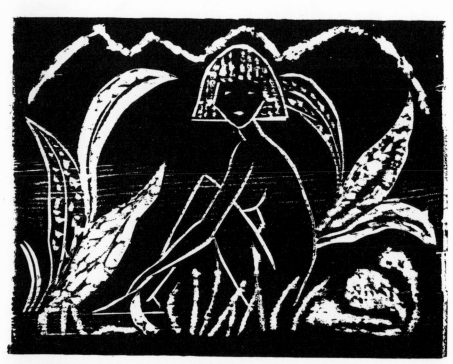

60. Müller

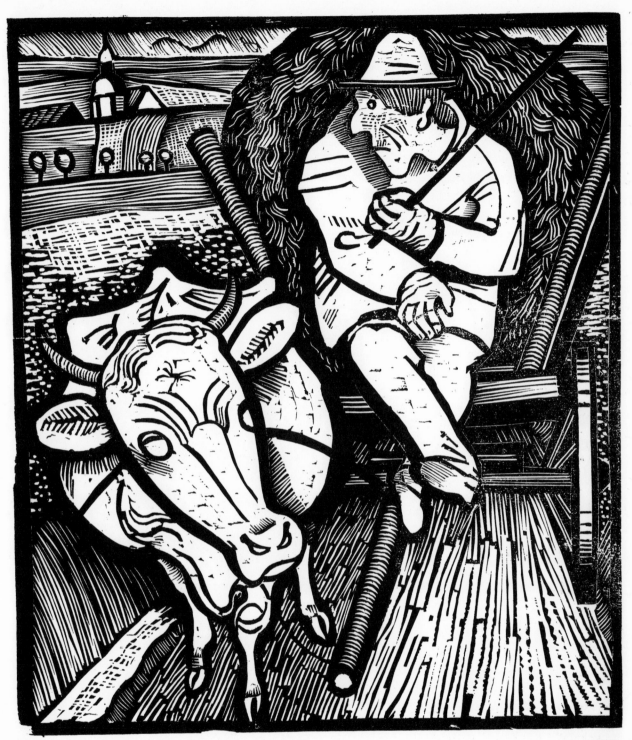

61. Marcks

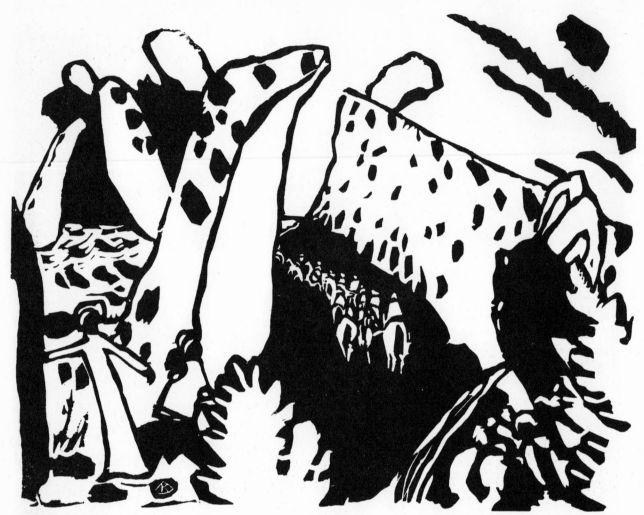

62. Kandinsky

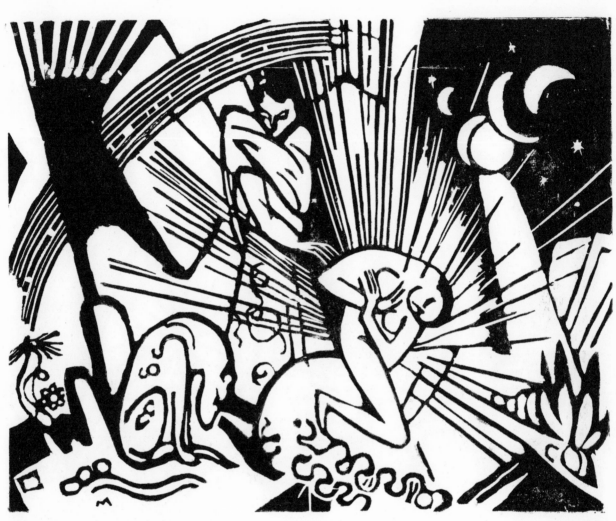

63. Marc

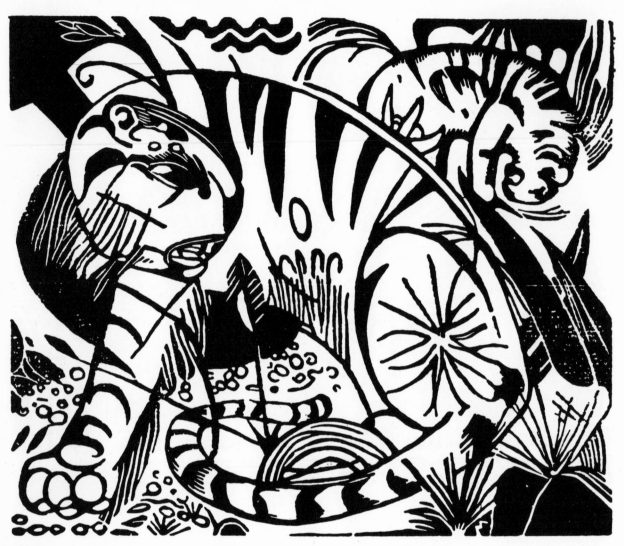

64. Marc

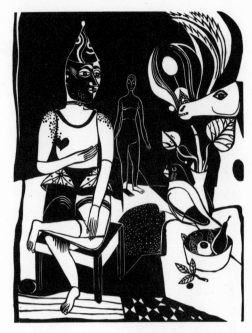

**67. Campendonk**

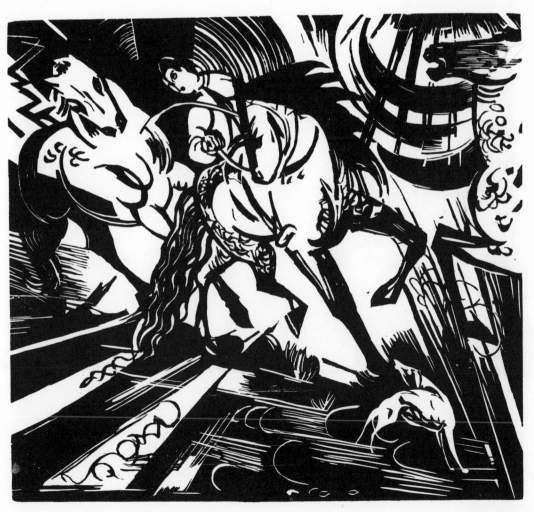

**68. Marc**

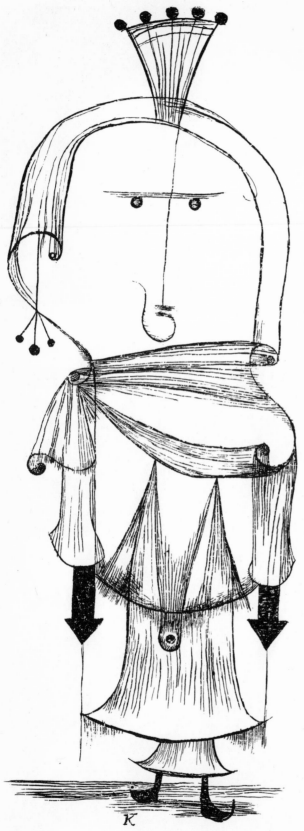

69. Klee

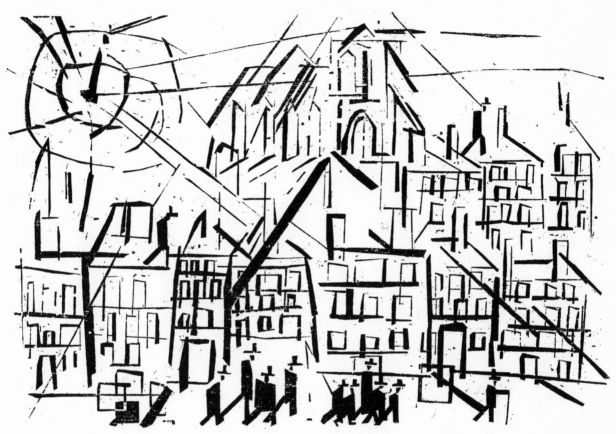

72. Feininger

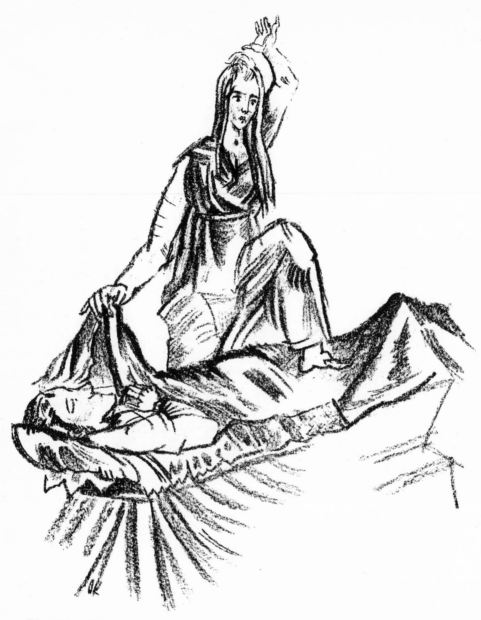

**73. Kokoschka**

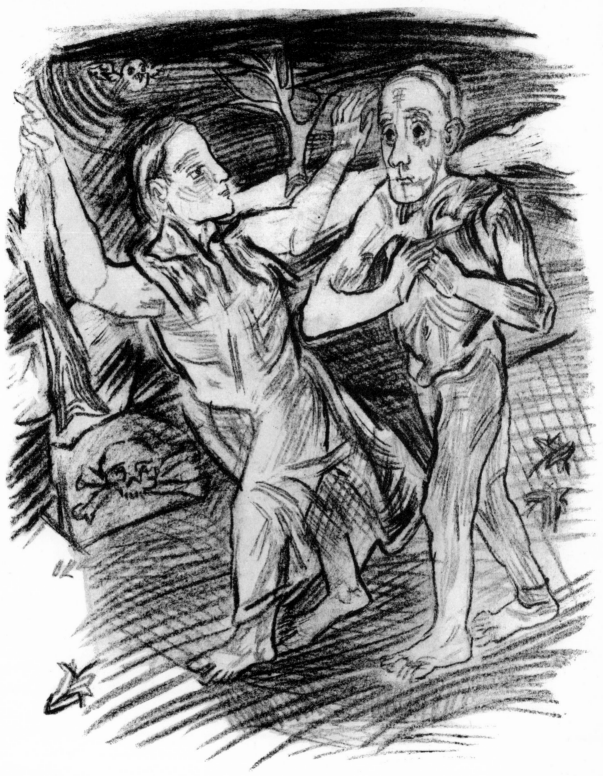

74. Kokoschka

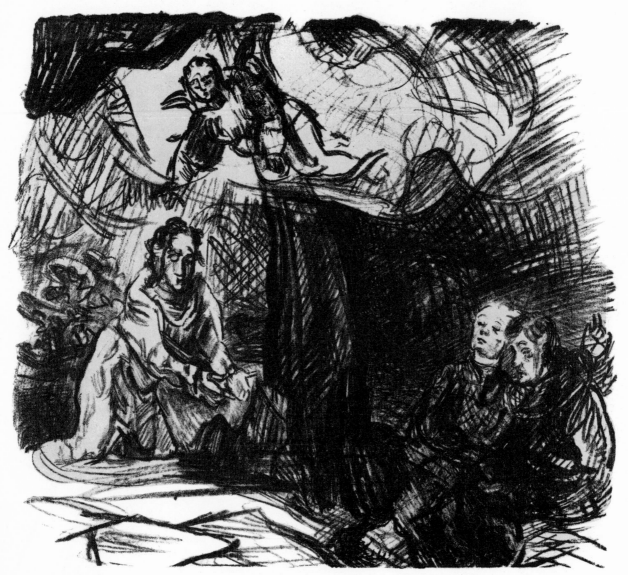

75. Kokoschka

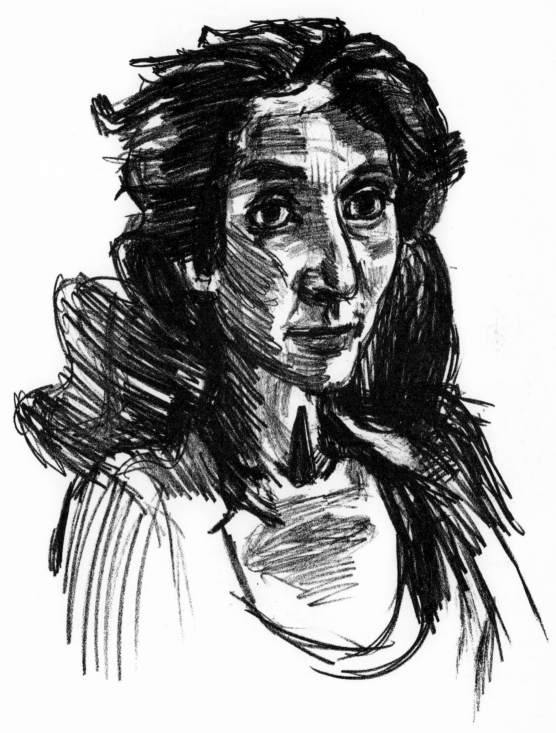

**76. Kokoschka**

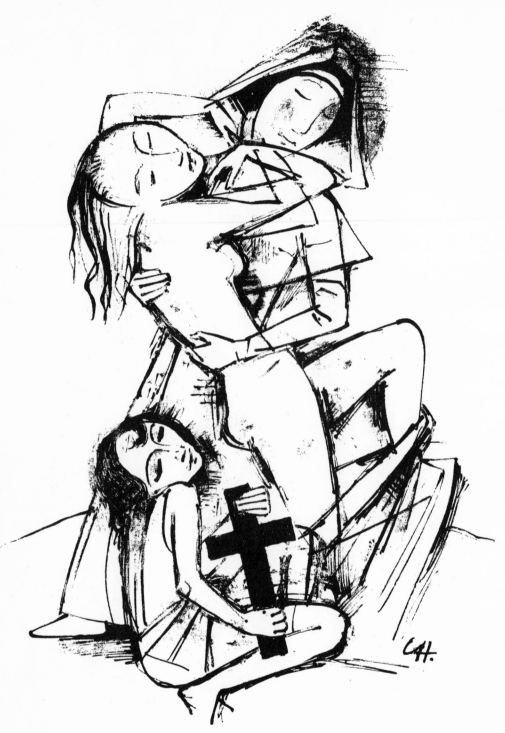

**77. Hofer**

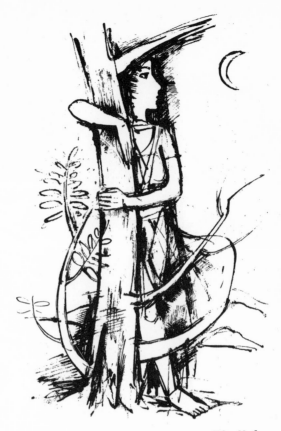

78. Hofer

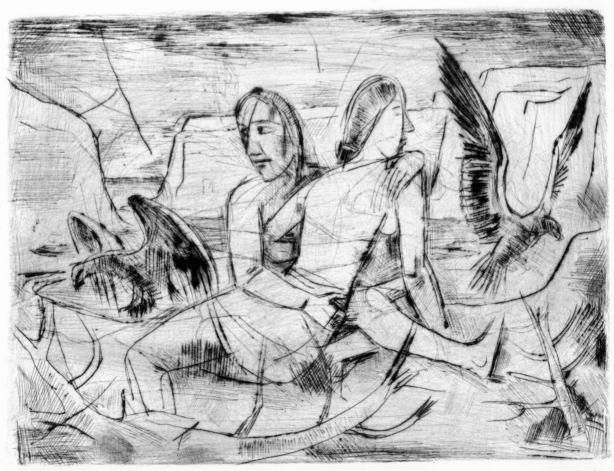

79. Hofer

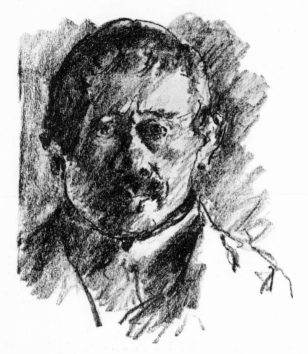

80. Corinth

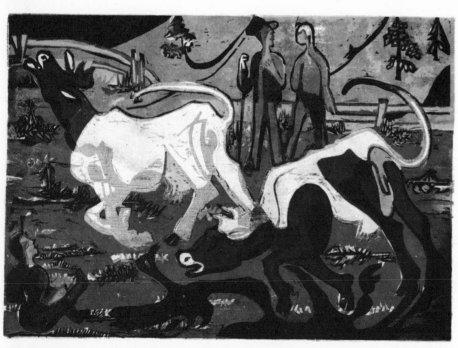

81. Mataré

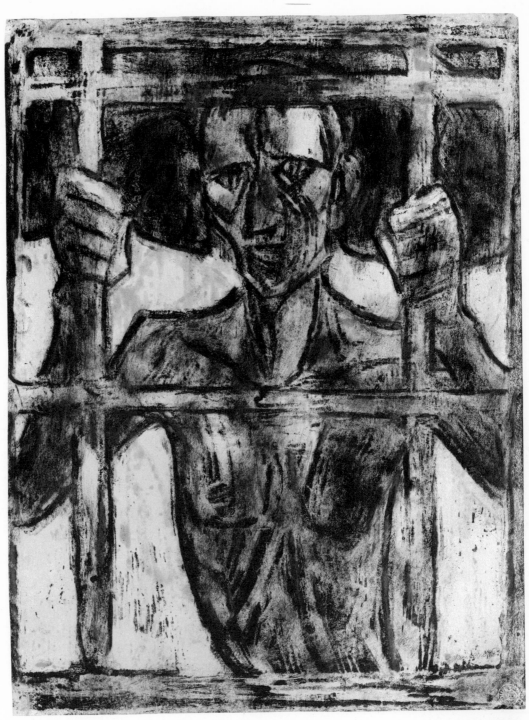

**82. Rohlfs**

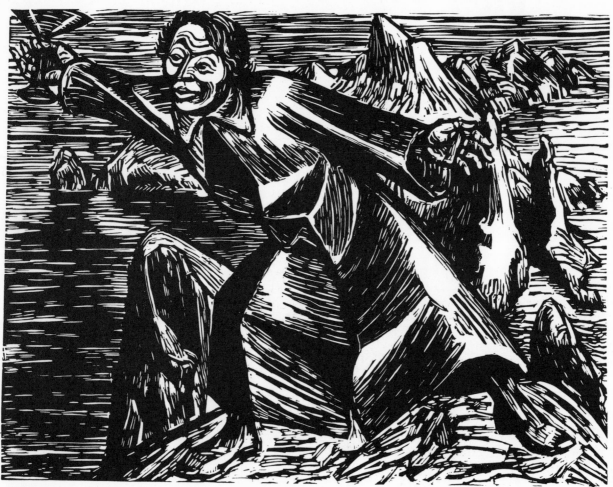

83. Barlach

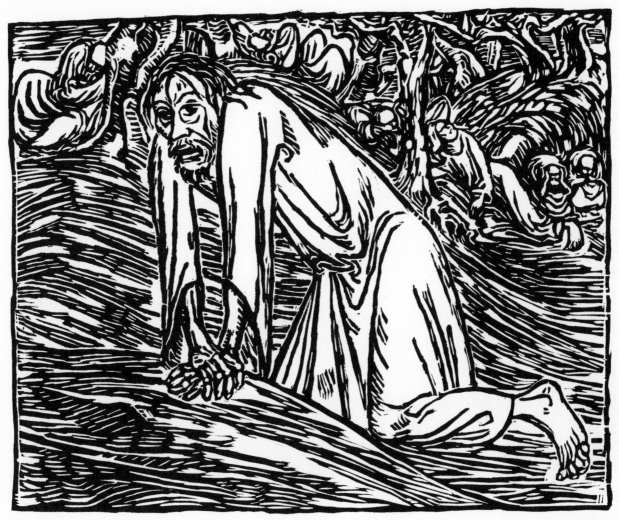

84. Barlach

**85. Barlach**

86. Barlach

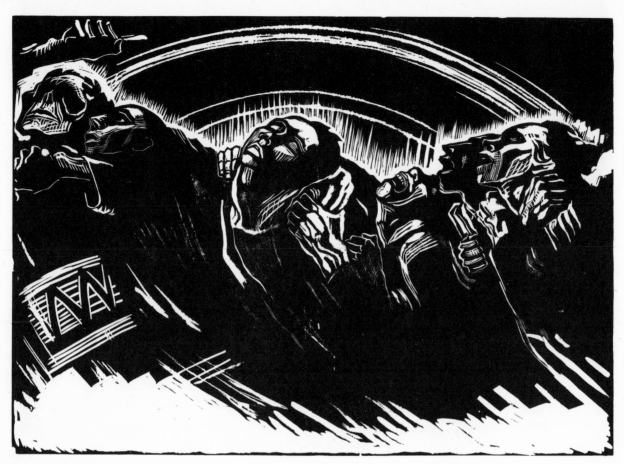

87. Kollwitz

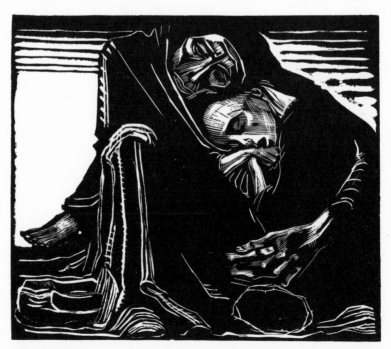

88. Kollwitz

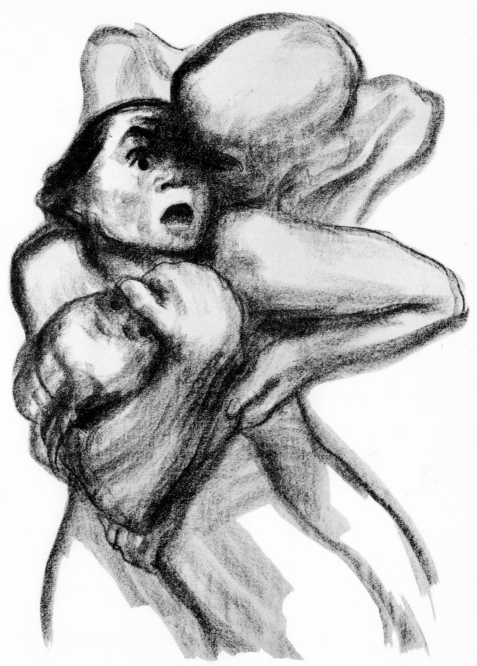

89. Kollwitz

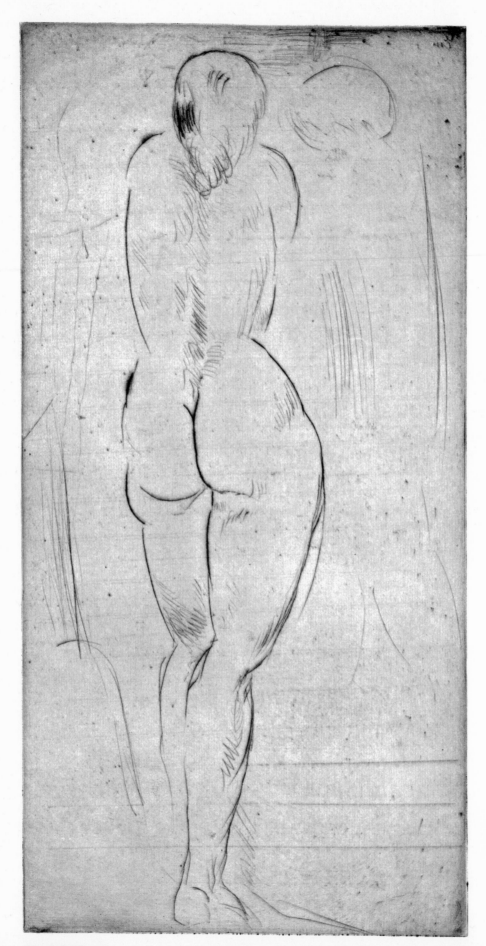

90. Lehmbruck

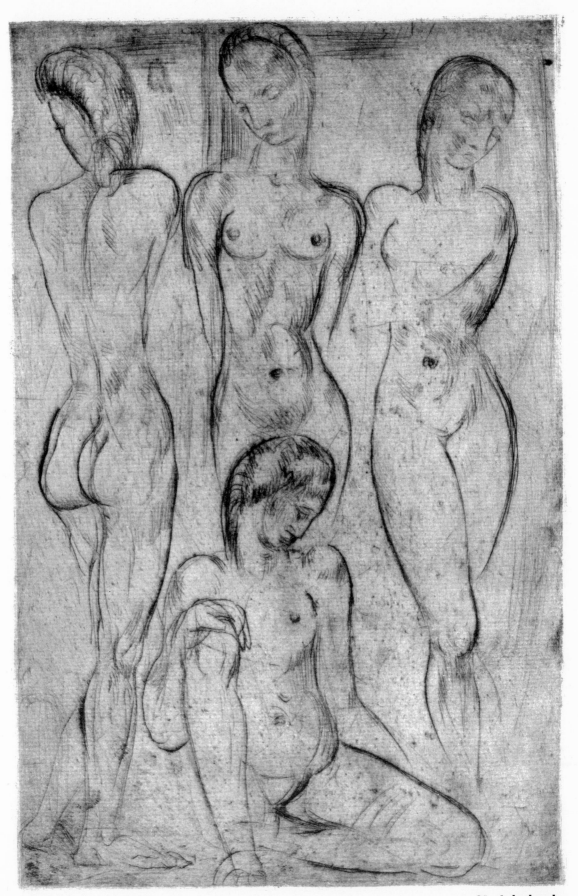

91. Lehmbruck

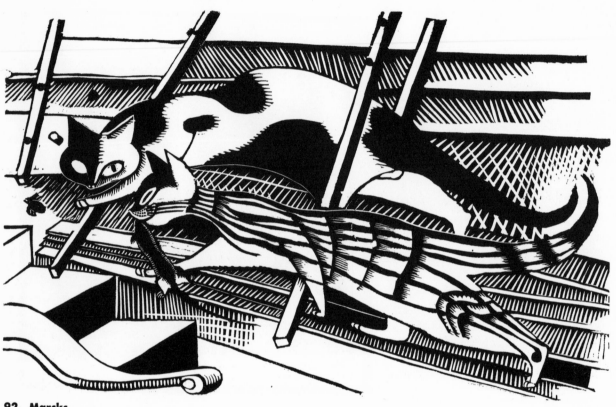

92. Marcks

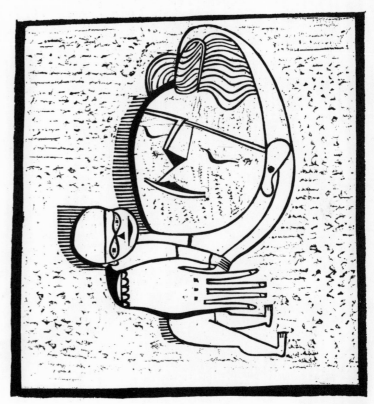

93. Marcks

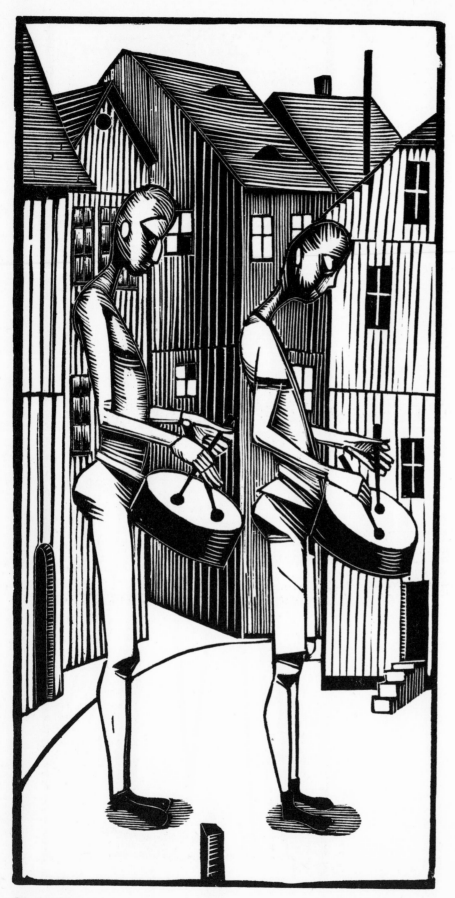

**94. Marcks**

**95. Marcks**

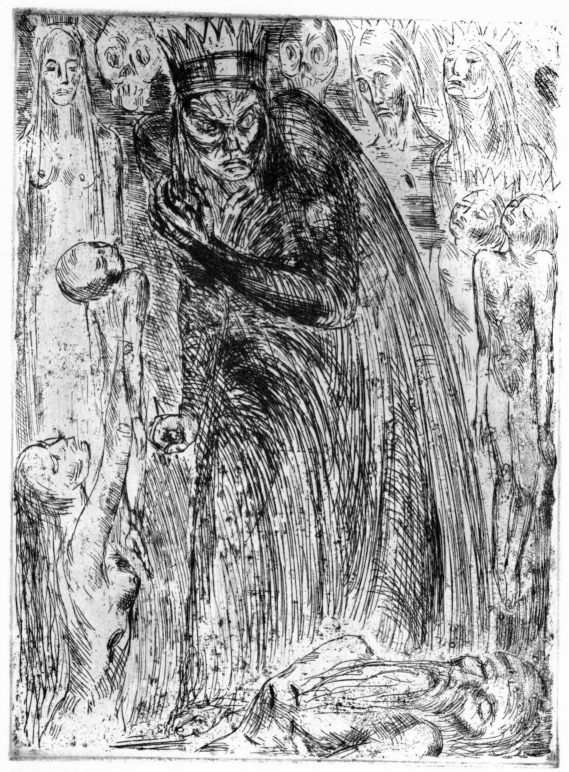

**96. Lehmbruck**

**97. Meidner**

**98. Steinhardt**

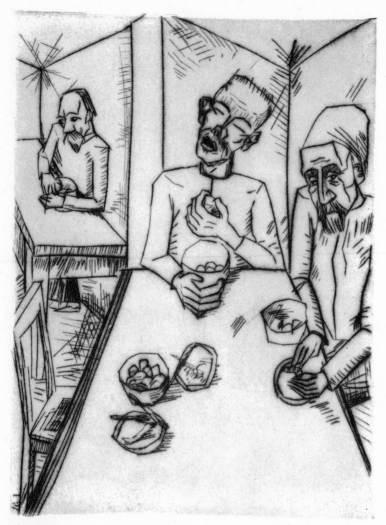

**99. Heckel**

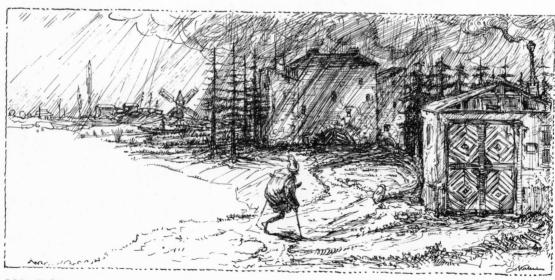

**100. Kubin**

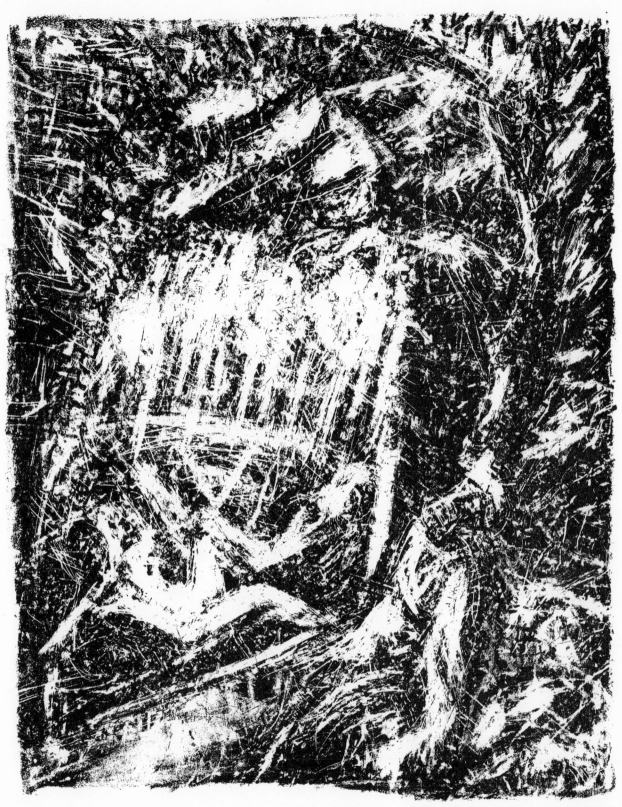

**101. Gangolf**

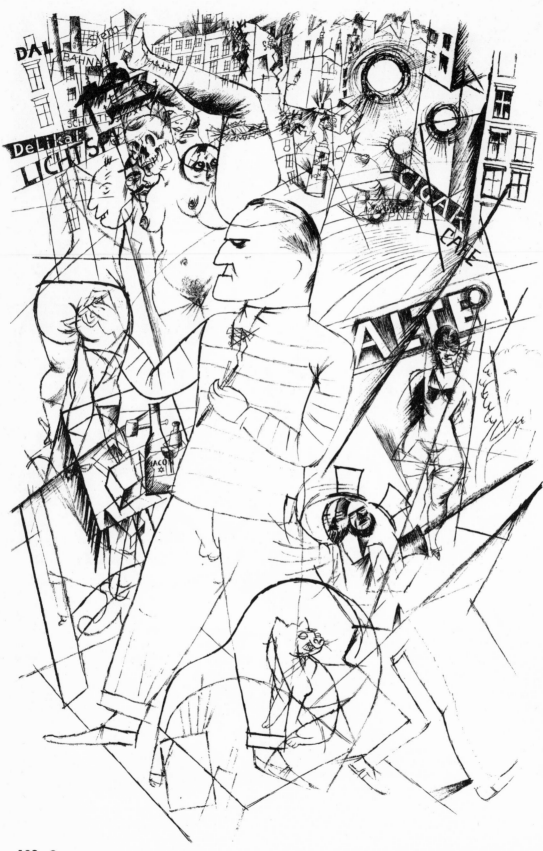

**102. Grosz**

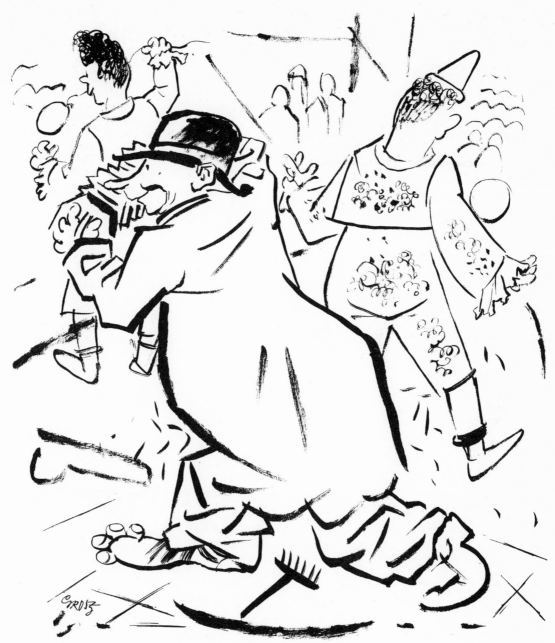

103. Grosz

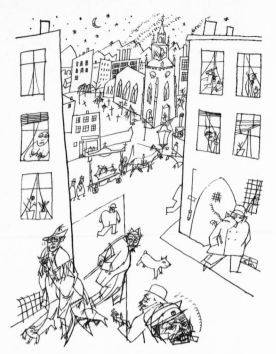

**104. Grosz**

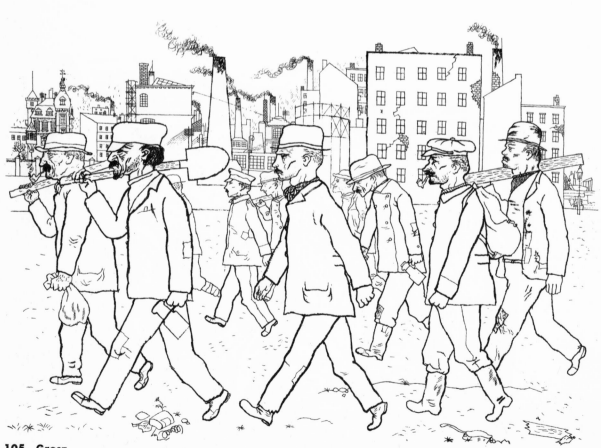

**105. Grosz**

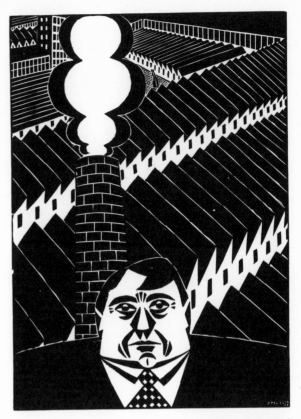

106. Masereel

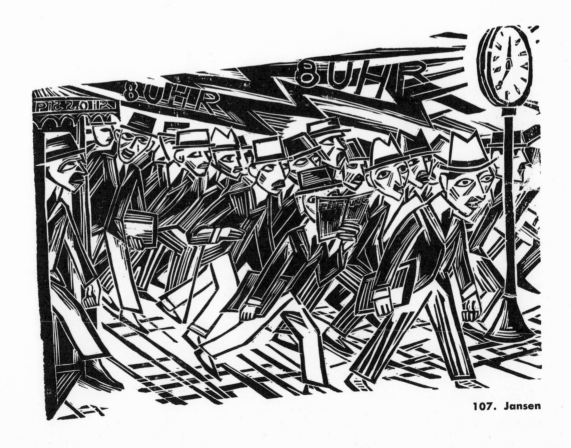

107. Jansen

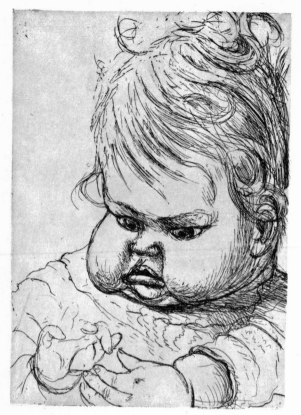

108. Dix

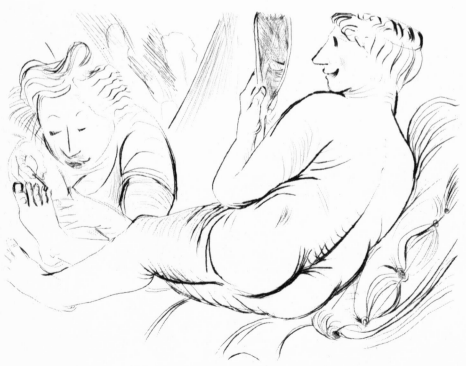

109. Kleinschmidt

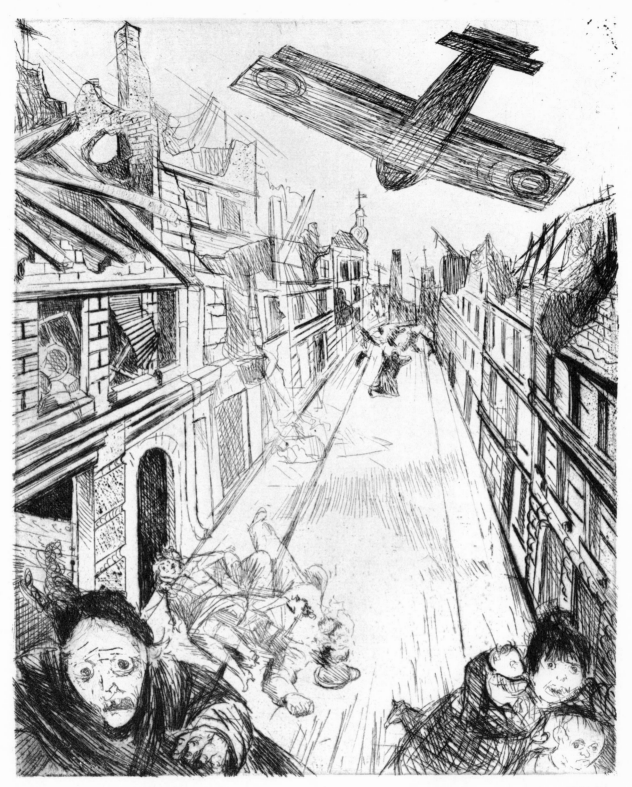

110. Dix

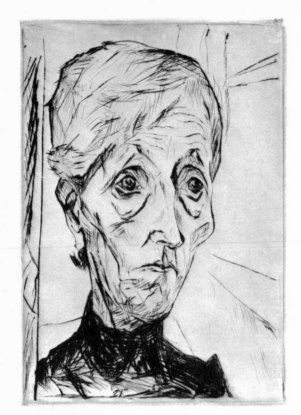

111. Beckmann

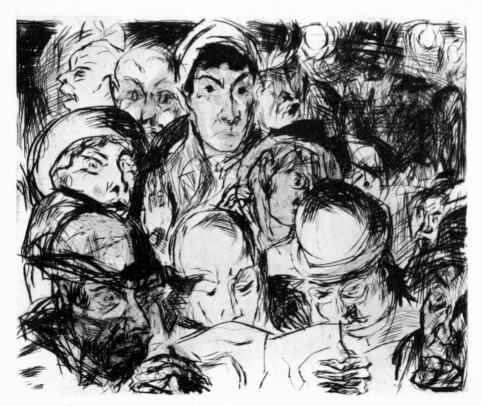

112. Beckmann

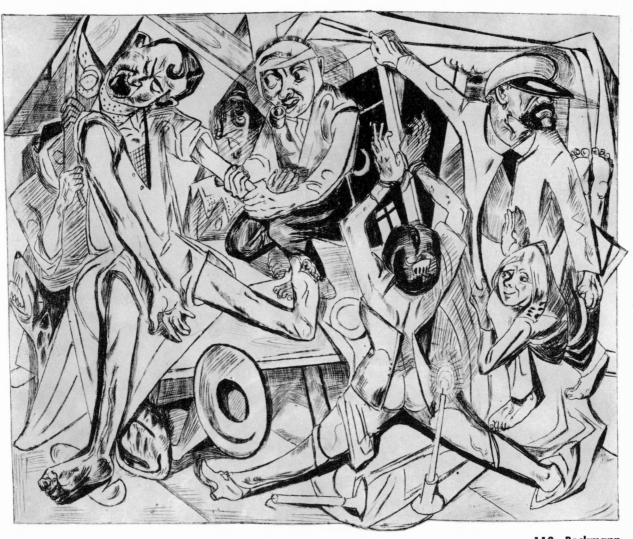

113. Beckmann

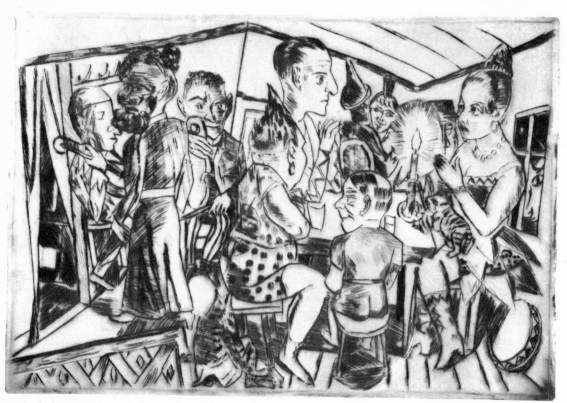

**114. Beckmann**

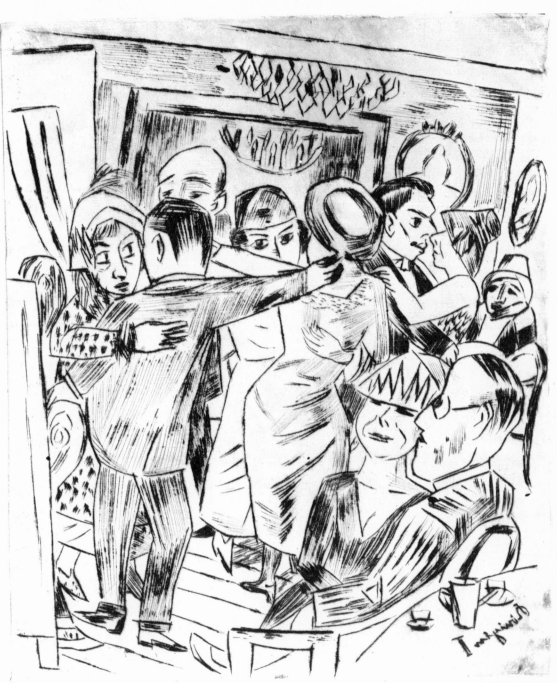

**115. Beckmann**

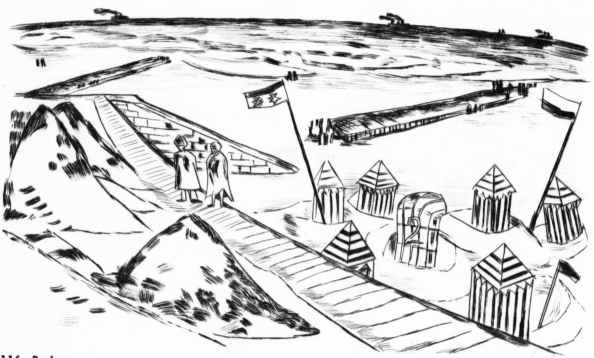

116. Beckmann

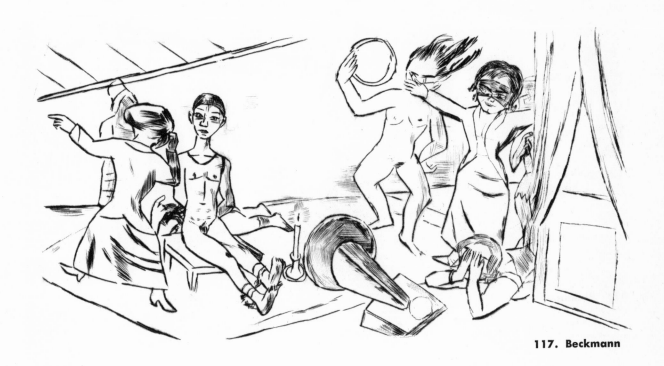

117. Beckmann

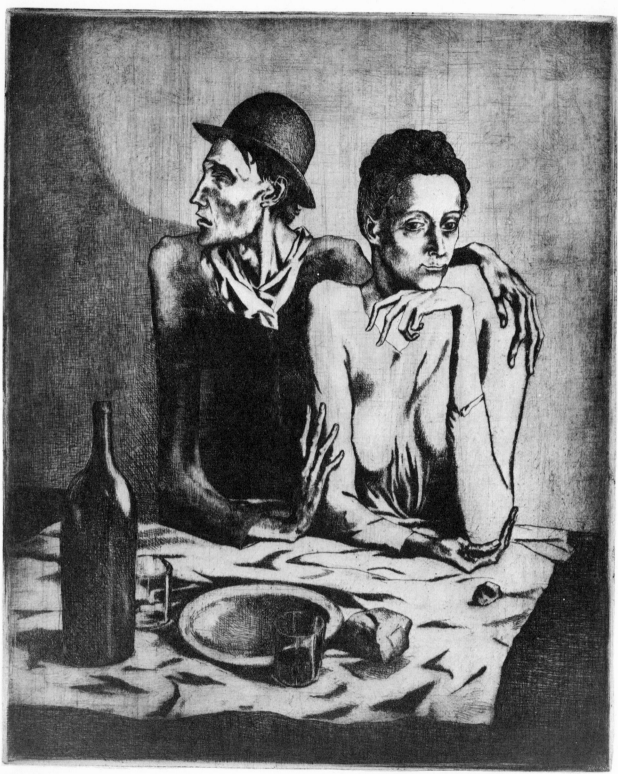

**118. Picasso**

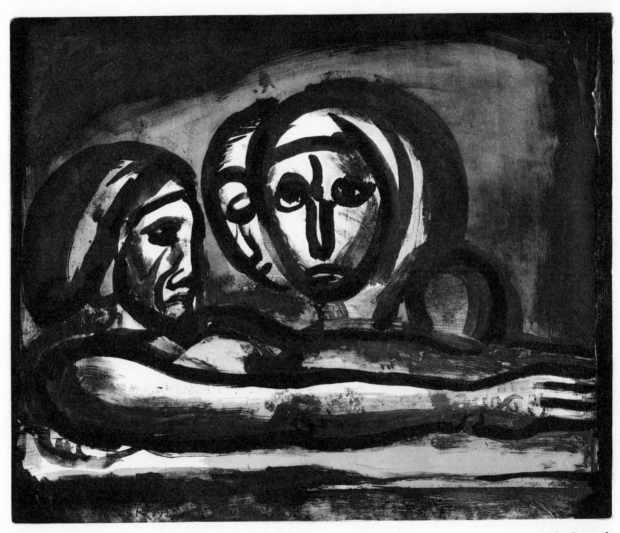

119. Rouault

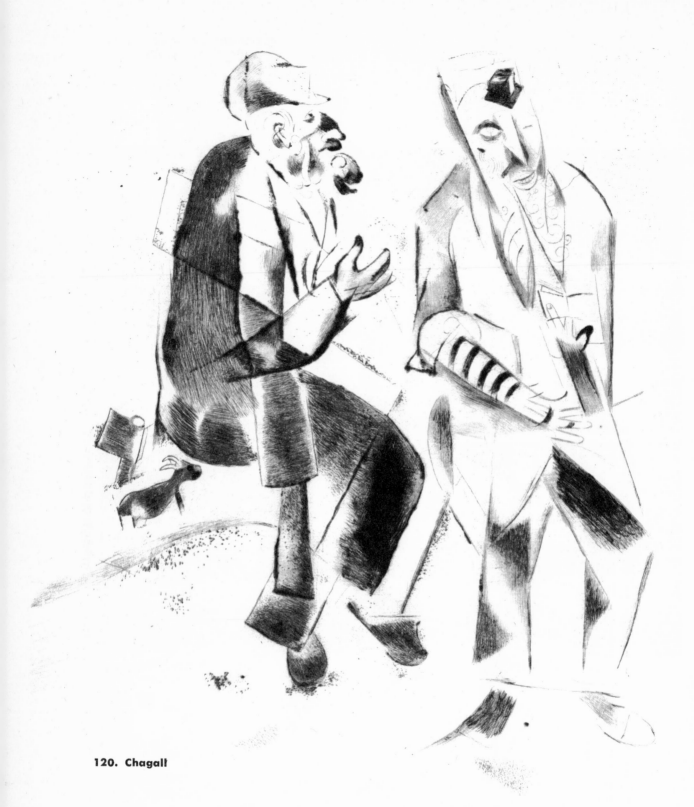

120. Chagall

121. Weber

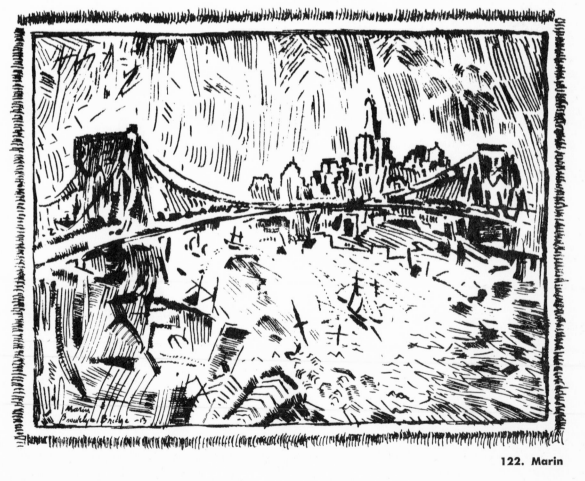

122. Marin